— PRAISE FOR SKY RUNNER —

*"Emelie Forsberg's Sky Runner isn't simply a training manual...
or a travelogue...or a cookbook...or a meditation on finding
a meaningful path through the mountains and through life.
Instead, it's all of these things and more, combined with stunning
photography by Kilian Jornet that will spur you to start planning
your next vacation immediately. An inspiring and open-hearted
testament to Forsberg's love affair with running."*

—Alex Hutchinson
Outside columnist and author of *Endure: Mind, Body,
and the Curiously Elastic Limits of Human Performance*

*"Emelie Forsberg is a genuine trailblazer, both on the mountain
and in life. She's boldly parted from convention and chosen a
path less trodden, one that is jagged and sheer, though infinitely
more rewarding. Sky Runner is visually and poetically stunning.
A must read for sky runners and anyone looking to be awed
and inspired, as I was."*

—Dean Karnazes
Ultramarathoner and *New York Times* bestselling author of
Ultramarathon Man: Confessions of an All-Night Runner

*"Emelie's experiences as an elite athlete are colorfully and
playfully portrayed in 'Sky Runner'. Her journey overflows with
life lessons that any athlete will enjoy and learn from."*

—Jason Koop
Director of Coaching, CTS, and author of
Training Essentials for Ultrarunning

BLUE STAR
PRESS

Published 2018 by Blue Star Press
PO Box 8835, Bend, OR 97708

contact@bluestarpress.com | www.bluestarpress.com

Photography | © Kilian Jornet (unless otherwise noted below)
Page 9, 49, 50, 53 | Martin Fryklund
Page 10/11, 13, 14, 17 | Dolomites Skyrace photo archive
Page 67 | Simeon/iStock
Page 68 | Maxim K/iStock
Page 126 | Emelie Forsberg
Page 143, 144, 148/149, 150 | Lyndon Marceau
Page 158/159 | Daniel Prudeck/ShutterStock
Page 168 | v.apl/ShutterStock

First Published by Gawell Förlag, Sweden in 2018
Publisher (Sweden) | Charlotte Gawell
Graphic Design | Kai Ristila
Editor (Sweden) | Malin Berman
Translation from the Swedish original into English | Sara Orstadius
Proofreading | Miles Avison

ISBN 9781944515737

Printed in China

11 10 9 8 7 6 5 4 3 2

This book is for informational and educational purposes. Please consult your healthcare provider before beginning any exercise program.

EMELIE FORSBERG

SKY RUNNER

FINDING STRENGTH, HAPPINESS, AND BALANCE IN YOUR RUNNING

TRANSLATED FROM SWEDISH BY
SARA ORSTADIUS

BLUE STAR
PRESS

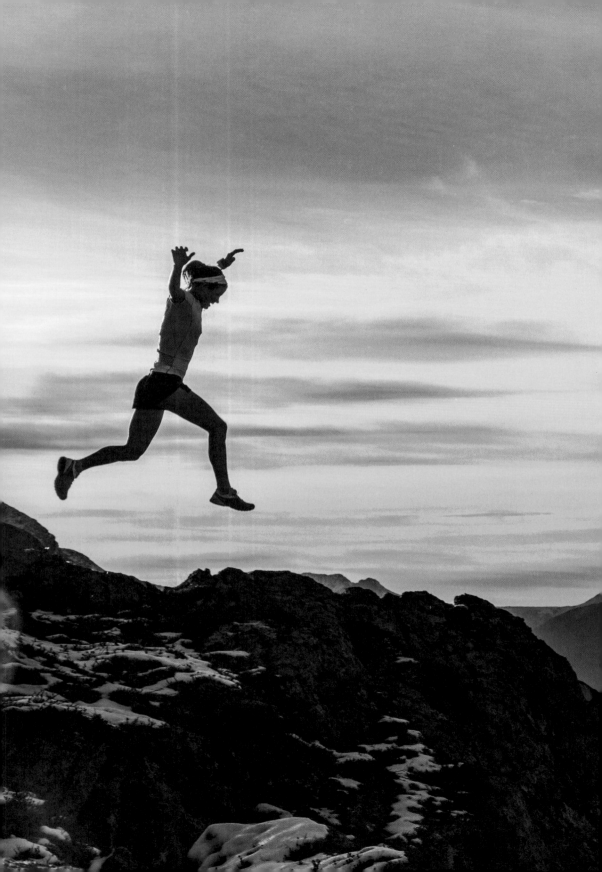

CONTENTS

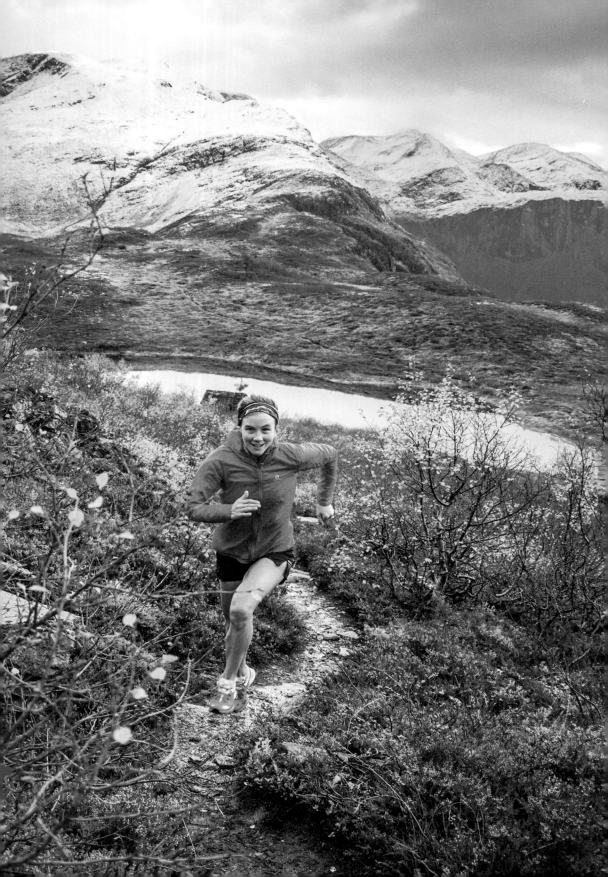

RUNNING IS
THE GREATEST

Running has always been a part of my life in one way or another. Since childhood, there was always running: sometimes more and sometimes less, but always constant, like a good old friend. I ran to friends' homes, between the school buildings, and as a complement to ball sports and climbing. In 2008, the friendship developed into something much bigger; slowly, running became the center of my life and everything started to circle around it, like planets around the sun. Different aspects of my life are important to me, but running became the greatest.

I wanted to know everything about running: to learn how my body reacts to running short and long distances, and in different places. I was running and learning more about it, just because I loved it so much. All I wanted was to be able to run the next day, too.

I subscribed to running magazines and devoured everything. But soon the basic exercises and tips those magazines offered weren't enough. I started to look for information on the Internet about the anatomy of the body, to understand how this fantastic thing—running—really works. It was not the training itself, or even training schedules that I was interested in. I was curious about the human body and its capacity for running; about how far into the great, wide eternity it could take me.

▲▲

PREFACE

It's as if it all happened overnight. I went from being the girl who loves the mountains and running to being a professional sky runner participating in international competitions, and a celebrity in the sport. It goes without saying that it's been a long road, but while decisions have been big and life-changing, I've been very much guided by my thoughts about what is important in life.

I've always liked sharing the things I love—things that enhance my existence, things that matter. I started blogging in 2010, for my own sake more than anything. I mostly shared beautiful mountain excursions, but also small, joyful snippets from everyday life. The year after that, my blog found a new home at *Runner's World*, where I became a regular columnist. Since then, I have continued posting items big and small on social media nearly every day. I'm not working according to any plan, and I'm not motivated by how many readers I have. I just want to keep going in the same spirit, because I like it.

I hesitated when approached to write a book. Who am I to be writing a book? And what would it be about? One thing I was sure of was that I didn't want to write about every step I've run in my life. But when I started thinking about it, there were plenty of other things I wanted to share, things that needed more space and which I wanted to get down on paper. I had thoughts and ideas that deserved to survive the fleetingness of the digital world, perfect for inclusion in a book.

I wanted the book to be about life. And as running is such a big part of my life, it turned into a book about life told from a running perspective—what running means to me, where it has taken me, what it has given to me and continues to give me every day. It's a declaration of my love to running. And yes, because running is life, it's also a declaration of my love to life itself.

I have run thousands of miles thus far in my life. I cannot share every step, but I will tell you about some of the steps that have meant something to me in different ways—in different places and at different times, as well as my thoughts about them. I hope it warms your heart to read these pages, and that I can impart both the desire to train and the tools to become a better runner. But above all, I hope I can offer you the inspiration to nurture and affirm your love for life and running. ▲▲

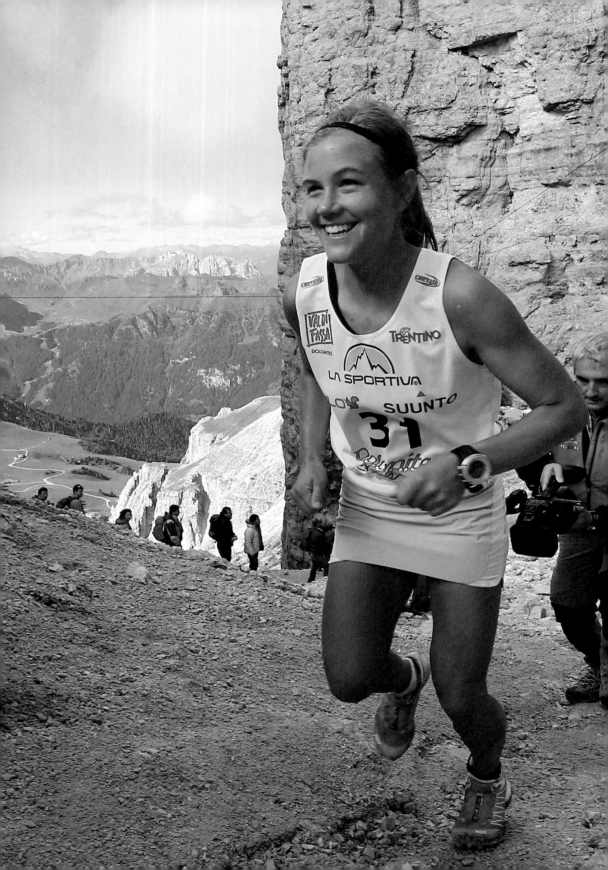

CHAPTER 1

[COMPETITION]

Drive or just that little extra?
About my first race as a professional and
about running without having competition
as a goal. Exercises that inspire and
challenge through contrast.

— CANAZEI, THE DOLOMITES, ITALY, JULY 2012 —

I look at my watch. It says 8:15 pm. In 45 minutes it starts, the *Dolomites Skyrace*. "It seems like a big race," I think to myself as I walk toward the starting line. There are hundreds of runners in colorful outfits. My teammates on the Salomon team are already warming up. I guess I should, too. I start jogging. At that moment I have no idea what awaits me, and what a door-opener this race is going to be.

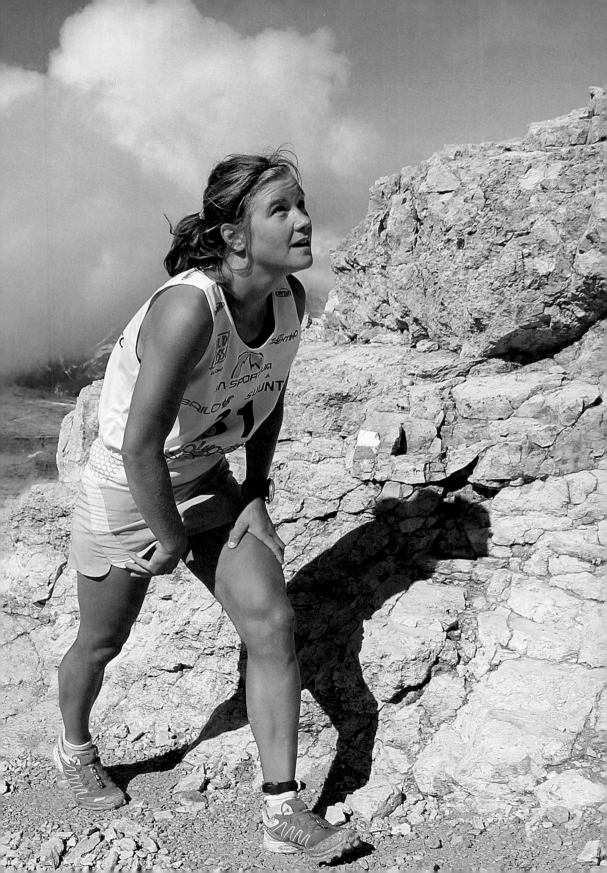

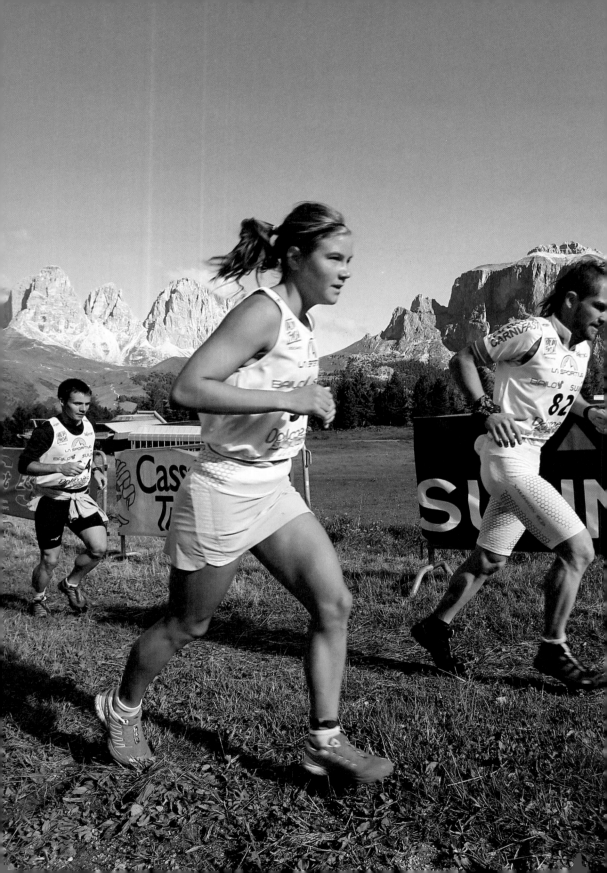

THE START

After the warm up I stretch a bit before entering the starting area. Almost all of the faces are new to me, faces that a few years later will be so familiar that some races feel like family gatherings. But at this point I only know a few from the Salomon team. I wish them good luck and most of all, enjoy! The race starts, and an eight mile climb awaits, to the summit of Piz Boè. That summer I mostly trained back home at Sweden's High Coast, along with a trip to the small mountains of Jämtland, so my uphill training has not really prepared me for what I have in front of me now.

I join Mireia Miró and Kasie Enman, two sure-footed mountain goats. For a couple of miles I follow along, observing their pace and rhythm. But something does not feel right. Is this the way it is supposed to feel? Do I want to just follow and monitor the other competitors? I don't want to think any complicated thoughts. It's a competition, and all I want to focus on is putting one foot in front of the other. I decide to stop thinking about what others are doing; the only things I can control are my own actions and how I dispose of my energy.

THE MOVEMENT THAT IS RUNNING

I slow down a bit, they disappear and I stop thinking. My god, what a relief! The only thing that matters now is putting one foot in front of the other. The breathing. The movement that intensively strives to lessen resistance and make every step as light as possible in order to minimize energy consumption. The movement that is running. To take me forward and upward as easily and quickly as possible.

As we approach the aid station, I hear a lot of noise and music. Wow, what a fiesta! This is like Vasaloppet, the cross country skiing race back home, but much more remote. Did people really hike up here to cheer for us? How amazing! They must love this sport—but then, so do I! I am fighting to turn my thoughts inward again. Do not think too much now, Emelie! But I cannot hold back a big smile to thank everyone for their encouragement and for how they are cheering!

One third of the climb is done. I long for the summit. I am curious about what is to come: the descent, and how my body is going to react to running at 10,000 feet above sea level after the oxygen-rich air at the High Coast. I am curious about what is behind the mountain. It

This terrain reminds me of home: the trail runs over slippery roots and muddy soil, and small rocks and bushes surround us. It's a big contrast to the harsh, alpine summit I just left behind. And suddenly I'm leading the women's race!

is a nice feeling, like enjoying candy: you know that the nice taste will last for a while, and yet you impatiently want to chew it, to try a new flavor as soon as possible. That's how it feels. I want a new flavor, a better one, and I know it will come. I'll soon reach the summit. So I take in the moment: the long climb, my legs working, and my breath, and I tremendously enjoy finding harmony in the movement.

Second aid station. The crowd is even larger here and my smile grows bigger. It gives me so much energy to see all these people out in the mountains! Next is a mile of traversing a long, flat stretch before the last steep climb toward the summit. I start to feel the altitude. On my last climb, I need to use both arms and legs—my whole body in a symbiotic movement—to find the fastest and most efficient way up, in a mix of running and climbing.

SPLIT TIMES

The summit is rapidly getting closer, or rather, I'm getting closer to the summit. I look around, amazed. What a view! A big crowd is waiting here as well, and again I have to smile and thank everyone for their support. I eat a gel and drink some water, and set my mind to downhill running. I get the split times for the women ahead of me: I am two minutes behind Kasie, and three behind Mireia.

The descent starts with a steep, narrow couloir with a chain to hold on to. I love this terrain, and I'm fast! The contrast to the long and slow climb is huge, and I love contrasts. They enrich our lives, and running in particular. I pass several of the men that were ahead of me. This is my thing. Everything flows, I know exactly how my body moves in this terrain. After the couloir, a technical trail with a lot of loose rocks awaits. I'm fast here, too. This terrain reminds me of the old pebbled beaches at home, only much steeper. On this

type of ground you have to move lightly and quickly, to flow with speed. After this comes another climb, and then there's only a mile-long descent to the finish line.

CATCHING UP

Just where the climb starts and the terrain is fairly easy with open rocky flats, I catch up with Mireia. "Hi Mireia! Come on, let's go! This is so much fun, isn't it?!" We run together with a sense of playfulness, as if we are flying. I continue in my own flow, and soon I catch up with Kasie. It is so much fun to see them again, and catching up gives me so much energy!

The high, alpine, rocky terrain is behind us now, and we have reached the forest. This terrain reminds me of home: the trail runs over slippery roots and muddy soil, and small rocks

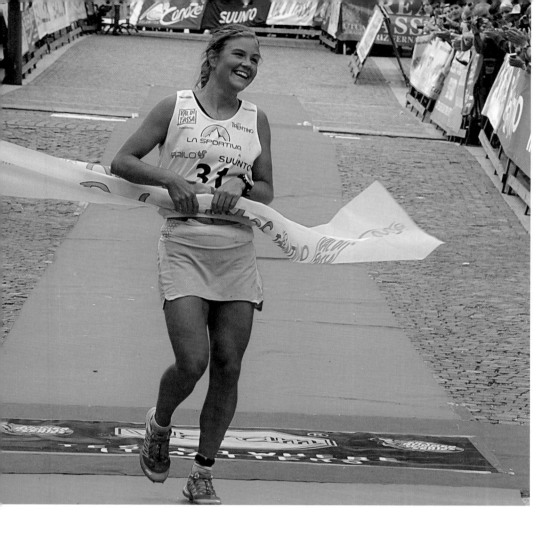

and bushes surround us. It's a big contrast to the harsh, alpine summit I just left behind. And suddenly I'm leading the women's race!

I try not to get swept away in daydreams about maybe winning. Me? Winning? Again, I have to force myself to turn my thoughts inward. My body senses the mile-long descent, and I know I need to focus to keep the flow over roots and rocks. The shorter and the more technical the trails are, the more concentration is needed. During longer races it is essential, however, to let go of the concentration on the descent to save energy.

Then I reach the gravel road, which soon leads to the paved road to the finish line. Even though my legs are tired, it is so nice to run on even ground, to up the speed. The only resistance is my breath. What freedom! From the infinite views of the high summit above, down to Canazei village in less than an hour. The body is a fantastic creation!

Okay Emelie, focus now, only the present moment, no more thoughts. The closer I get, the louder the cheering. A quarter-mile from the finish line, lots of people are standing along the road, cheering. *Dai dai! Bravo!* It is such an adrenaline rush as the red carpet suddenly appears. What a day! I raise my arms toward the sky and cross the finish line as the first woman. I am also running into a new chapter of my life—my life as a professional mountain athlete. ▲▲

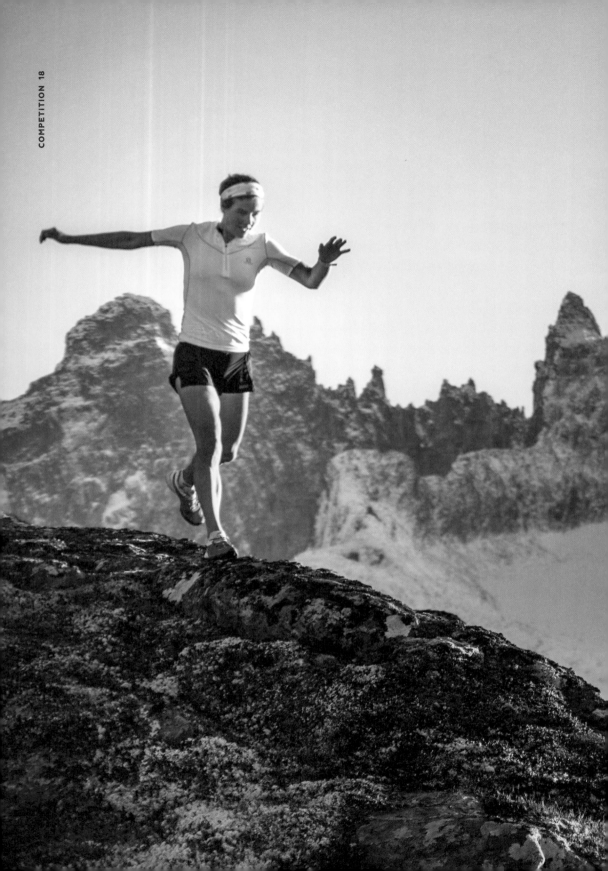

RUN OFTEN! RUN FAR!
RUN SHORT! RUN FAST!
RUN SLOW! BUT NEVER
RUN AWAY FROM THE JOY
OF RUNNING.

DRIVE

To race is something special, to stand on the starting line with people who love the same thing as I do. The excitement and anticipation are palpable. To be able to perform what is expected from us, after all the preparation and eternal training hours. For five years now, I have been competing at the highest level in mountain running and ski mountaineering, and the joy has not wavered. The only thing that has possibly changed a little is my drive.

During my first two years as a professional athlete (2013 and 2014), I was driven by a pure curiosity to explore places and races; I did not care much for results. My training was spontaneous, just as it has been since I quit ball sports in high school. I am convinced that this way of training is just as good as following a training regime.

It might sound contradictory, but it can be even harder to train without a schedule. The many options almost make the freedom overwhelming. In contrast, if you've written down that today is a rest day, intervals tomorrow, and a longer workout with a heightened tempo at the end the day after tomorrow, then that is just the way it is, and you don't really have to think much more about it. Without any plan, you will have to know exactly where your limit is between fatigue and laziness. And if the weather is nice and the conditions are perfect for long days out in the mountains, the time just flies by and it's hard to limit yourself.

Training without a coach or a training schedule is great freedom, but also great responsibility. It is my responsibility alone to perform, to take care of my body, to develop and to get stronger. At the same time, I have the freedom to train according to the season and the daylight, and to adjust according to the weather and my own physical and mental shape.

After a couple of years, running became more of a job to me, and my approach to it became more professional. I wanted to see how good I could get at different distances and I wanted to do my job well—for my own sake and for the sake of those who believed in me. ▲▲

"To race is something special: the motivation takes us to the start line; we are about to achieve our goal. But even more special and more important to me is finding the motivation to run without having winning as a goal."

— EXERCISES: RUNNING —

CONTRASTS

*Try to challenge yourself with something
that contrasts with your normal running training.*

I think contrasts make us better runners. Contrasts help us to keep up our motivation, and help us to improve on our weaknesses. I love contrasts, so I run all types of distances, but I work extra on those where I am not that strong. Since I have a talent for ultra-distances, I put extra effort into shorter training sessions and shorter intervals.

What about you? Are you most comfortable on a 5 km run with high intensity, on a slow 10 mile run with lower intensity, or with short intervals on the track? Try to challenge yourself with something that contrasts with your regular training.

IF YOU PREFER SLOW RUNS
Do some repetitions of 1,000–2,000 meters on a track, paved road, or gravel road.

IF YOU PREFER FAST REPETITIONS
Try to go for a longer run, on or off trail. You can define what constitutes a long run, as it's so different for everyone. It can be 1 hour or 4 hours; the important thing is to challenge yourself!

IF YOU REALLY WANT TO CHALLENGE YOUR ENDURANCE
Look at a map of a forest or nature reserve close to where you live. Plan for half a day out and bring a friend or two. Pack a backpack with clothes, food, and a first aid kit, and just go!

IF YOU WANT TO CHALLENGE YOUR EXPLOSIVE POWER
Plan a shorter session on a track or gravel road. If you have never tried track running, you should be a bit careful with longer distances to start. The same goes for running on hard surfaces. It takes awhile for your body to get used to it, and you do not want to end up injured. When I started with this type of training, I never ran more than 5 miles at a time. I am very restrictive when I run on new surfaces; I want my body to get used to it. I do flat intervals to gain some speed and to improve my running stride. Flat intervals definitely make for a significant contrast to mountain running!

LADDER
Start by running 1,000 meters, then 800, 600, 400, 200, and 100 meters. Continue by turning the ladder and going up to 1,000 meters again. Rest for 30 seconds by standing or jogging between each interval. Alternatively, you can do it the other way around and start with 100 meters and go up.

LONGER INTERVALS
Do repetitions of 1,000, 3,000 or 5,000 meters. The number of repetitions depends on how far you usually run. If you are not used to this it might be enough to run 3 x 1,000 meters.

The farthest I usually run is either 8 x 1,000 meters, 3 x 3,000 meters, or 3 x 5,000 meters. It depends what I'm training for, of course. Before a race like the Swedish Lidingöloppet, it could be useful to run 3 x 5,000 meters at competition speed. Very hard, but so rewarding! I rest for one to two minutes between the intervals, by standing or jogging.

Measure the distance you plan to run and write down your times as you run. Then you can compare and analyze it later!

Think it through: what time and distance suit you? If you have not run more than 5 miles before, then the long run does not have to be more than 8 miles. And if you have not run flat intervals, you can start with three or four repetitions, not more. But most important, enjoy the contrasts!

THE RUNNING STRIDE

I believe the running stride is something very individual, yet I am sure that everyone is born to run. We are simply shaped differently and have differing physical makeups, which means that we need to find our own running stride and our own training. I am no expert and it is hard to give general advice, but some things to think about include:

➜ Try to keep a natural pelvic position. Do not tilt the pelvis forward to arch your spine, but do not tilt it backward either.

➜ Make sure you have a straight and relaxed back, and try to keep your shoulders relaxed.

➜ Use your arms! A good arm pendular motion makes it much easier to find your running stride!

I cannot say anything about landing on the heel, as I do not run that way myself. Many runners put down the rear part of the foot first, but I have always landed on the front of the foot, and I believe research proves this technique to be gentler on knees and joints.

One thing that has helped me to achieve a better running stride is to visualize pushing my foot hard toward the ground each time I put it down. Then my leg gets a push and my leg pendulum increases.

I put my foot down just in front of my hips. Because of the speed, I land when my weight is exactly over my hips, with my heel, knee, and hip in a straight line. If possible, ask a friend to film you so that you can examine your own form.

WE WERE ALL BUILT
TO RUN—ALL YOU HAVE TO DO
IS PUT ONE FOOT IN FRONT
OF THE OTHER.

CHAPTER 2

[DECISIONS]

The simple, the predictable, and the unknown.
About finding a balance between living simply
and predictably, and at the same time
wanting and daring to let go.

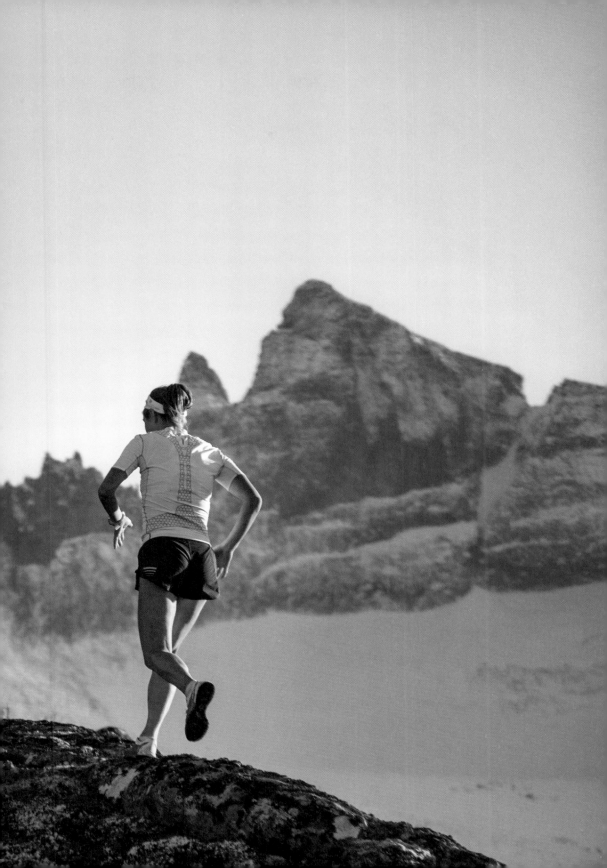

[DECISIONS]

— INDEPENDENCE PASS, COLORADO, 2013 —

I wake up to my sleeping bag having slid down a bit, and my bare shoulder is freezing. Shivering, I crawl all the way in again and pull the sleeping bag around me like a cocoon. I look at my watch and it's almost seven. Time to turn the heat on before breakfast. I stay in my sleeping bag for another few minutes before I quickly jump up, turn on the heat, and then quickly crawl back into the sleeping bag. It'll be about ten minutes before the temperature in our camper van is comfortable enough to get up.

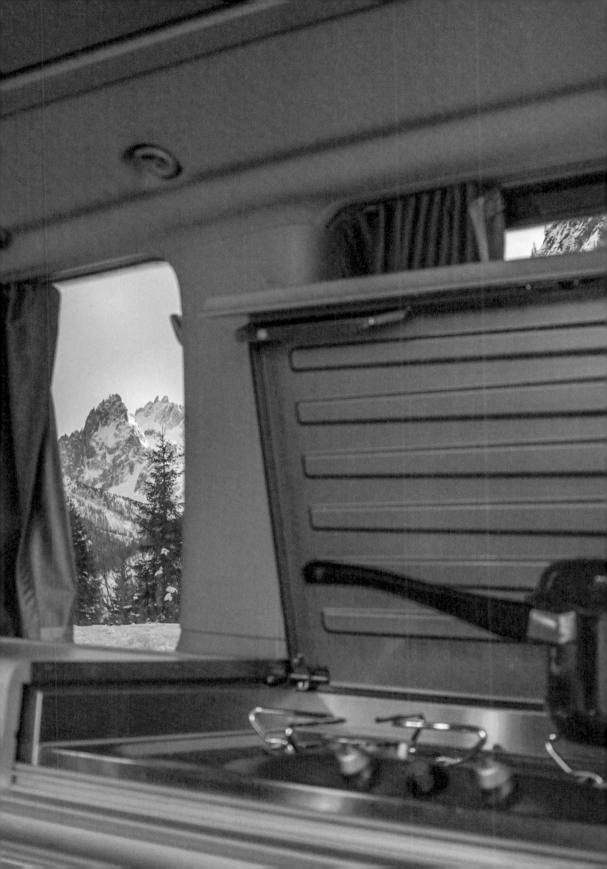

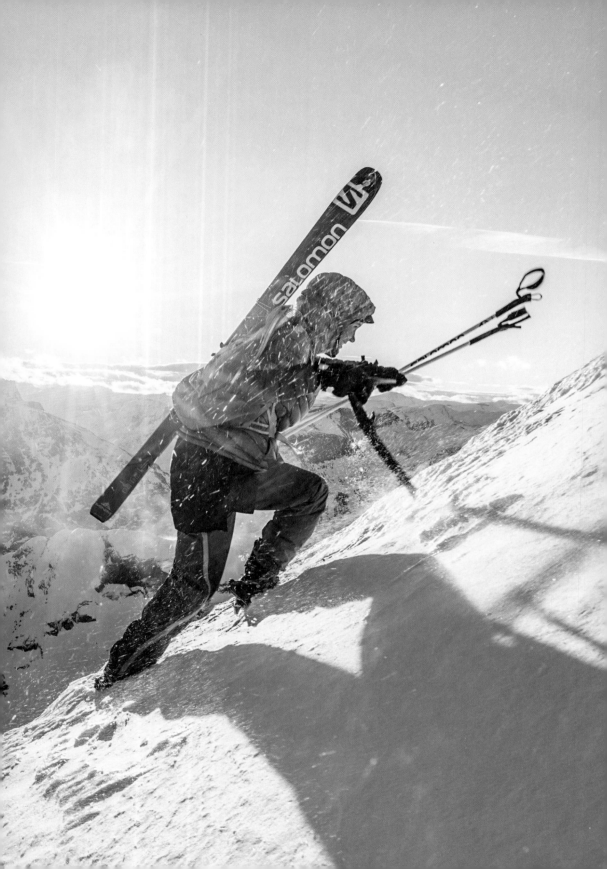

ROUTINES

It's time to get up. My morning routine in our camper van starts with boiling water for coffee. Then I put on my training clothes with down clothing on top to keep warm. When the water has boiled, I make my coffee, scrape the frost from the window and wake up Kilian. Kilian is my partner both in the mountains and at home. We have parked our mobile home in a mountain pass at about 10,000 feet above sea level, close to Leadville, Colorado. We had the opportunity to stay in the United States after a race in San Francisco, and wanted to take the opportunity to explore some mountains in Colorado on skis. At the same time, we would train for the world cup in ski mountaineering. It looks like it's going to be a nice day.

After breakfast, our training day starts. I have two racing seasons each year, one season running and one season ski mountaineering. I am almost entirely ski-borne six months a year; the other six I only run. It's December now, and I'm skiing. The first training session of the day is a long one. We always start at the same time to see how the snow conditions are at the summit we are headed for. I finish training one hour before Kilian and return to the van. By then it's warm and welcoming. When the sun is shining, it heats up so quickly as it's so small! 25 square feet with everything we need: bed, table and kitchen. I stretch a bit in the warm sun before I go inside to heat up the leftovers we are having for lunch. As Kilian washes the dishes after lunch, I have a cup of coffee while looking out of the small window at the big mountains outside. There are only a few hours between the first and second training sessions, but in this limited space there is not much else to do besides stretch out on top of the bed and just be.

After lunch and a rest we do the afternoon session, prepare dinner, have a cup of tea, and then it's time to go to bed again.

It's so very easy to live this way, with nothing to worry about: nothing to clean, no bills to pay, no Internet to surf. The only things we need to think about are food, heating, and getting today's work done.

THE SIMPLE

It may not be optimal for an elite athlete to live in a camper van, to be cold, to not be able to shower after training, to not even be able to stand upright at home. But for a limited amount of time it is still so very worth it, though it's not a five-star hotel. This simple life makes me realize what is really important: to be warm enough, get food for the day, and do something I enjoy. I guess that is basically what most people strive for. It's something we have had inside us for thousands of years, something we forget while stressing about

The simple, the predictable, and the unknown are three key phrases that I in some way always strive to combine. Two of them are the exact opposites, but I do my utmost to try to strike a balance between them.

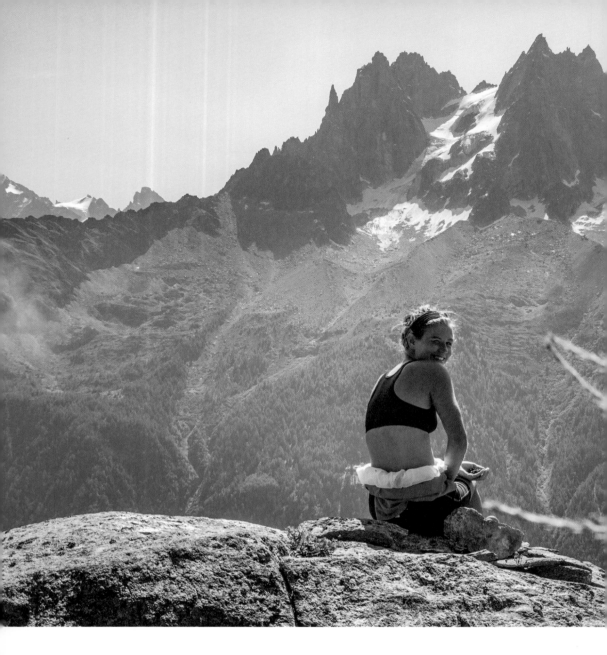

choosing education, paying back mortgages, and saving money for our holidays.

I have always been fascinated by the simple. When I was fourteen, I spent the summer at home in Nora with my dog, Nero. It was quiet. There was porridge for breakfast. Rice and vegetables for lunch and dinner. Walks, runs, and swims. It was simple and monotonous living, and I realized at the time that I actually liked it. I had everything I needed. I was happy.

THE PREDICTABLE AND THE UNKNOWN

One of the advantages of starting at university was that I knew what I was going to be doing over the next couple of years. It was my fixed point, around which my life circled. I knew on which days I had to prepare for exams, and now and then I had some time off. Although I mostly took distance courses, changed university from Umeå to Tromsø, and combined my

regardless of whether I was at university or if I was climbing somewhere in Europe. To bike, run, or ski to university was an easy way to get some exercise and the feeling of freedom that I needed in an otherwise regular life. I also had the unbeatable feeling that my body could take me anywhere I wanted.

In November 2011, after three years of biology studies and less than a handful of local races with good results, I was asked to join the Salomon Sweden Trail Team. Imagine getting running shoes and some training clothes for free! And trips to different races—why not? It was such great fun racing, anyway. In April 2012, I was invited to a training week in Greece with the international Salomon Team, a big event for the best runners in the world, with new product testing and meeting people at the Salomon head office: massage therapists, marketing people, photographers, and a whole bunch of other people. It was such a circus, but what a commitment! All these people worked for and with the athletes. My sport was huge here! Imagine that the sport I loved was loved by others, too, and that people could make a living from it!

After that week, I came home to the Tromsø winterland again, but with many new thoughts about my sport. I studied, took exams, and rode my telemark skis. Simple and normal— the life I was so at ease with. At that time, one of my lecturers ran a project in Northern Norway, and was looking for field assistants. I knew I was a good candidate. I also knew that this project could lead me to many other possibilities for future studies, maybe even a master's course. As I was contemplating this, I got an invitation to join the international Salomon Team for another meeting. I also heard suggestions about other races I could get invited to if I wanted, like the world cup of sky running or mountain running. So there was even a world cup in the sport I loved the most!

my courses as much as possible to suit my mountain life, my studies were always there. It was what I prioritized.

My studies became the "predictable" in my life. The "unknown" were all the places I visited during my time as a student, places to which I chose to bring my distance courses. It was possible to combine the predictable and the unknown with the simple, to always make my life as uncomplicated as possible,

How was I going to be able to maintain the joy and the simplicity that I like so much if my passion became my work?

MY JOB AND MY PASSION

It would be impossible to do fieldwork in the middle of nowhere and at the same time travel around racing. I could not solve that equation. The fieldwork was an opportunity. This was what I had studied for, something that later could open doors to other jobs. Contacts. Experience. The predictable. I wanted to be a biologist, right? I had chosen this education, put in too much time to miss this opportunity. And for what? What is sky running, anyway? And what does it mean to run at the world cup? Was I supposed to become an elite athlete then? Was that even possible overnight?

Finally, and albeit with a lot of unanswered questions, I made the decision to make a living from my running, at least for the summer. It felt like a big decision. There and then it was probably my biggest decision to date. It felt fatal in one way, but in retrospect it was not that dramatic. The worst thing that could happen, I guess, was that I missed my chance to do fieldwork, maybe a year of university. I made the choice to go wholeheartedly for the mountain running. I opted out of the predictable to throw myself into the unknown. My passion was going to be more than just a passion.

And that was one of the reasons why the decision felt bigger than it was. There was an element of worry that was not connected to studies and fieldwork: was it possible to keep my eternal love for mountains and running and compete professionally at the same time? How was I going to be able to maintain the joy and the simplicity that I like so much if my passion became my work?

The summer exceeded all expectations. I won the entire sky running world cup, as well as my first 80 km ultra-distance race. The strange thing when I think back is that the victories were not that important in themselves; I did not think that much about them. It felt natural to run and I enjoyed life as a runner much more than life as a winner.

Autumn came and brought with it another big decision: was I going to continue to study or just go with this new life? Thanks to my successful sky running, I was offered a pair of light racing skis for ski mountaineering. It was not Salomon and I had no sponsor the initial years of skiing, but it just felt right to be able to train in the mountains during winter as well. Again, I felt that pang of uncertainty that makes life so exciting.

For a long time I had been filled with both envy and skepticism toward those light skis, with which people seemed to ski so fast. I had heard about ski mountaineering as a sport, a very big one in the Alps. Maybe I could train through the winter with this equipment? I was charmed at once by this new mountain sport. With the new light equipment it was even easier than with my old telemark skis. One summit became three or four summits. I could go wherever I wanted to—only my imagination and my body set the limits. With these skis I could continue as before; the light equipment just made me more efficient. I was sold!

The year 2012 became 2013, and I signed up for the open competition of a world cup in ski mountaineering. There was also a world cup in this sport! These fantastic mountain sports that were so big in the Alps were unbelievable. I started my new career with a victory in the open class, and a 5th place in the world cup. ▲▲

MY PRIVILEGE

In many ways, it is easy to live off my sport. But there are moments of doubt, of course. Not because it is too hard to train twice a day basically all year, but because I sometimes ask myself if what I do is worth it. Do I make the world a better place? I travel around to race. Sometimes I am successful, sometimes not. Sometimes it doesn't feel real, in the sense that I do not live and have a job like most others; that my big passion is also my livelihood. Maybe this feeling is amplified as I was never raised to live like an athlete. I had a "normal" life with work and studies until I was well over 20 years old.

To appreciate what you do in everyday life is the most important condition for happiness—something as easy as being fond of your morning routine, or taking time to meet relatives and friends, or to cook a good meal. When I doubt my decisions in life I always return to that. How can I not love this life? When I doubt whether what I do makes sense, I ask myself if it would make more sense to spend my days in a lab. I believe that the sensible thing is to appreciate what I do, and in some way feel that I contribute to the happiness of others, if only to a very small extent. My hope is that I can motivate others to take their time. Take time to run. To stop. To choose a life beyond the ordinary.

The greatest doubt I had before I chose to go for my mountain sports was whether or not I'd be able to stay in love with them. I loved them too much to lose them. So I just decided that if there was even the smallest sign of losing that love due to competitions and everything that comes with them, I would quit immediately. The decision would probably be difficult, but I would make it. The races and the life as a professional athlete were not worth living if my passion was not there—the passion that took me there in the first place. Any life whatsoever,

with whatever job, would be better if this love remained. It was my decision then, and this is how I have chosen to live since.

Now the unknown took over. Instead of the predictable with small doses of unpredictable episodes, the unknown dominated—the unknown life as an elite athlete. I had no template to follow.

As everything was based on me keeping my feelings for running simple, and the view that it is a privilege to be able to run, that was my focus. Choices about racing schedules, travel—and later also interviews and sponsorships—always came second. Because if you find what is important, what you want to prioritize, and then plan according to that, then my experience is that the rest will fall into place. Like if you buy a bag of stuff and know that there is only one thing in it that you really want, then you just have to handle the rest. There may be good and bad stuff in there, but if you are satisfied with what you really want then you are fine.

Dare to choose the simple life. To appreciate it. My safety net always came in the form of knowing that I can live simply. If the summer came and my new running career went pear-shaped, then I knew that I could easily go back to a simple student life with porridge, rice, and lentils, and that the mountain life around the corner would still be the best thing ever.

The simple, the predictable, and the unknown: three parts I strive to combine. I was always drawn to the unknown, to not knowing what tomorrow would look like. That attraction was bigger than the part of me that wanted to know exactly everything. Another part of me wants to plan several years ahead, to know exactly what I am going to do. These motivations and different ways of thinking have continued and will continue to meet and get on fine in my life. ▲▲

– EXERCISES –

DOWNHILL RUNNING

Prepare your body for the descent.

I love the feeling of fast and smooth movement downhill. It is a feeling of pure freedom! Almost without any effort I fly ahead; I barely touch the ground, just a tap now and then. Only the leaning of my body takes me forward!

It is important to have strong ankles and legs to avoid wearing of the joints when you run downhill. Here are two exercises for strengthening the muscles for downhill running. As always, it's important to have strong legs in general, so make sure you train your front thigh muscles as well as your calves.

TRAIN THE MUSCLES AROUND YOUR KNEES

It is also important to use the muscles around your knees, especially your *vastus medialis*, the round muscle on the inside of your knee, which is a part of your *quadricep* and works hard in downhill running. If your *vastus medialis* is weak, your knee joints will wear out a lot quicker. I usually train with a leg kick machine when I have access to a gym. When you sit down and move your legs up, your muscles work hardest in the extended position, so it's better to have less weight and keep your legs straight for a couple of extra seconds.

SLACKLINE FOR THE SMALL MUSCLES

Walking on a slackline is perfect training for the small balance muscles. On a slackline, you work with your ankles and knees on an unstable surface, which makes your lower legs strong—a great advantage in uneven terrain. If you don't have a slackline, a balance plate also works. I stand on one leg on the plate and swing the other back and forth. Your hips must be balanced, so make sure that your hip bones are level.

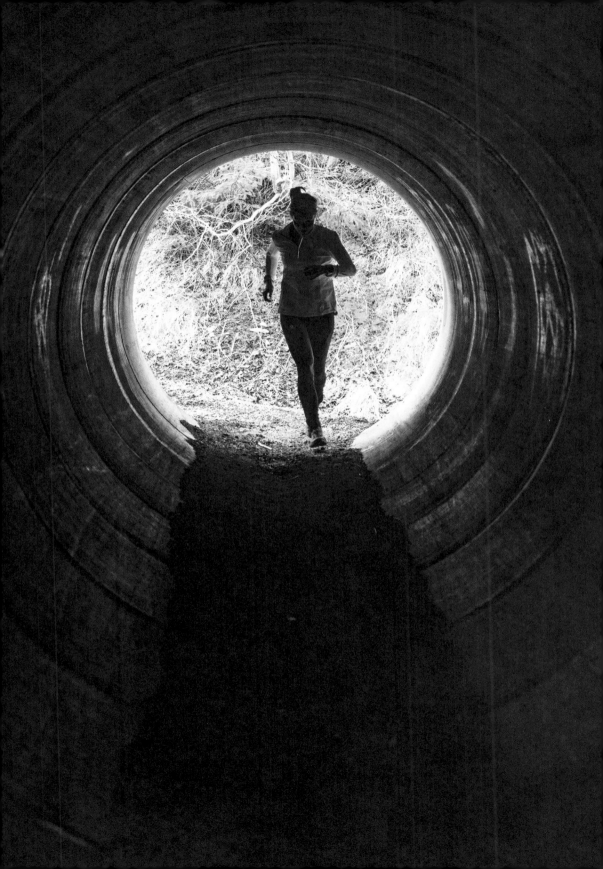

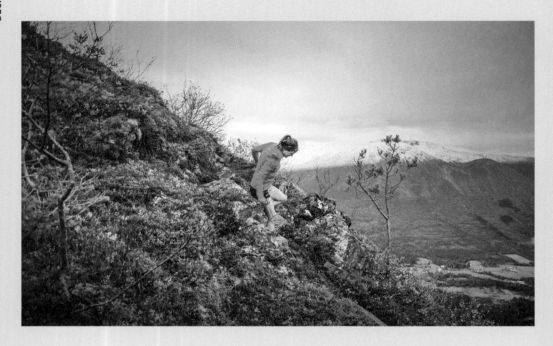

LOOK AHEAD

In order to have speed downhill, it's important to not look at your feet. You must look ahead of you to be able to plan each step. You can practice this! Try the next time you run downhill!

It's about choosing a good route the seconds before, memorizing it, and looking farther ahead! Seconds might sound short, but in ten seconds you can move close to a hundred meters. The more experienced you are, the farther ahead you can look in steeper and more technical terrain. When going slightly downhill on flat ground it is easier to keep your head up and look further ahead. Try to find your level!

USE YOUR ARMS FOR BALANCE

Use your arms to keep your balance! My arms fly in all directions when I run downhill, and my whole upper body is working to follow my leg movements.

Both your balance and center of gravity are changing all the time. This is what makes downhill so exciting: trying to be relaxed in the unknown at all times. Find balance in every step!

PLYOMETRIC TRAINING

To train your reflexes to become really agile, you can do plyometric training once in a while, where you try to harness as much power as possible in one movement, as quickly as possible.

Try, for example, drawing a line and jumping quickly from side to side on one leg. Focus on a soft landing and a quick step. Do not do this exercise at the end of a training session, as it is very demanding. Three to five repetitions per leg is enough.

Skipping rope also works very well when you alternate between your feet rather than jumping with both feet at the same time.

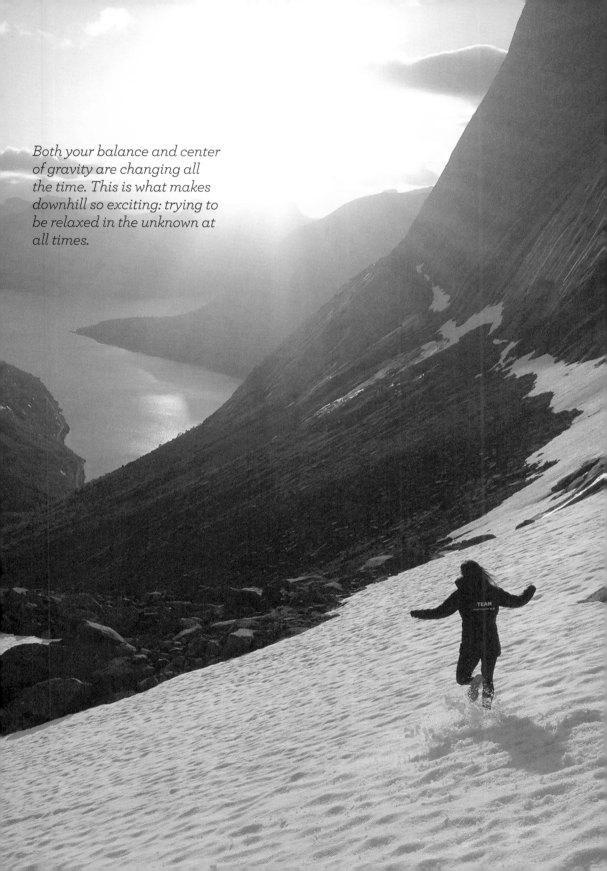

Both your balance and center of gravity are changing all the time. This is what makes downhill so exciting: trying to be relaxed in the unknown at all times.

I HAVE NOT ALWAYS BEEN AWARE OF MY LOVE FOR RUNNING— THE RUNNING WAS JUST ALWAYS THERE.

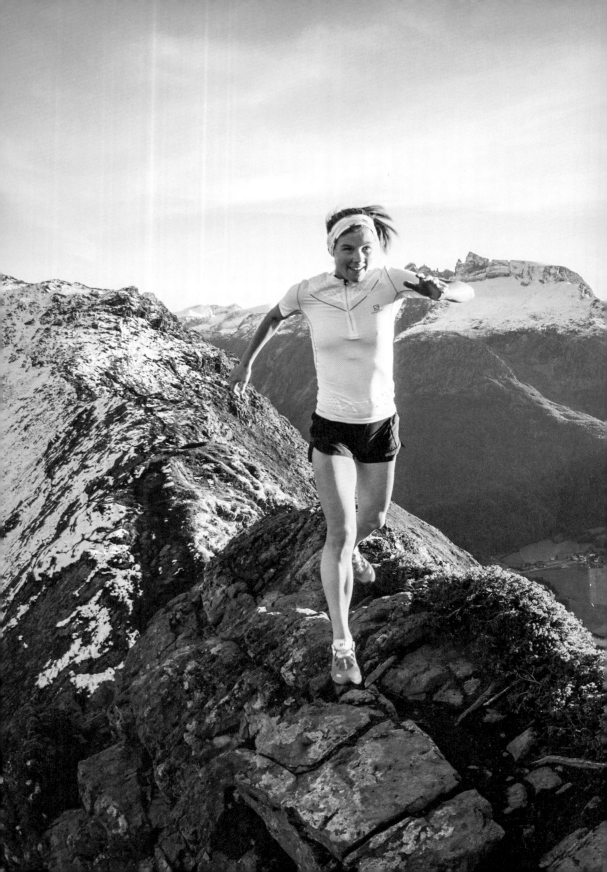

CHAPTER 3

[FREEDOM]

Playing for real. About daring to
choose unknown trails, daring to play—
especially when it's deadly serious—and
about training fartlek.

— **SKULE FOREST, 2015** —

At the High Coast where I grew up, nature is wild. The forests are old and playful, with big trees, hanging lichen, and a chaotic ground layer where you can barely see where you're treading if you dare to go outside the trail. Pebbled beaches expand with small and big rocks alike, and I play a game where I have to find the fastest way across. Smooth cliffs throw themselves towards the sea, and the sandy beaches feel eternal.

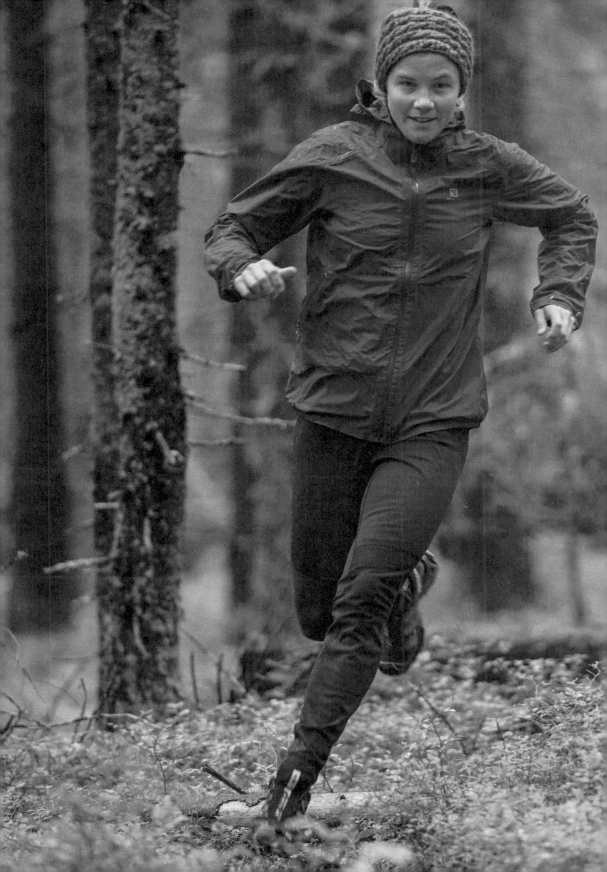

LET'S LEAVE THE TRAIL

A good friend and I are out running at home in the southern part of the High Coast. She is there for the first time and although the pebbled beaches, the mighty cliffs, the deep forests, and Slåttdalsskrevan are well known to me, I see them as if for the first time.

We are running along a path, sometimes talking, sometimes focusing on the running, letting our thoughts wander off—just how it is when you're out for several hours. On our way back, we see a beautiful little mountain, on which the bare cliff forms a higher plateau. We just have to go there. This means that we are going to be out for much longer than we planned, but to stay on our trail and miss this adventure is just impossible. We leave the trail and make our way into the forest. Moss covers the entire ground layer, and the terrain is immediately wilder than along the trail, requiring our full concentration to place our feet. Pitter patter, we run side-by-side. Sometimes my friend is faster, sometimes I choose a better route. We are focused now. And eventually the hill that we saw from a distance starts.

BY CURIOSITY AND DESIRE

It is exciting to leave the beaten track, and particularly to change the planned route on pure impulse. To reach the summit is a fantastic feeling. We did it! We made our way here because it looked so exciting and beautiful. Not because we had to or not because we planned to. It's fantastic, although it is nothing other than a detour from a path. We gave in to our curiosity and followed our desires and gained a whole new experience. We did not follow the trail; we gave in to our desire to discover.

It is typical of me to get lured away by my curiosity. It's what drives me: daring to give in to something that is not always planned beforehand, not always following the path ahead. Either I find a new, beautiful way, or if the terrain is too difficult, I just turn around and follow my own tracks back to the path.

The most important thing is to try. Sometimes when running, it's necessary to follow your thoughts and new ideas. Only those who do something wholeheartedly dare to let go, to leave the well-known and follow their impulses. This is how to get new perspectives and new experiences. This is so much more rewarding.

NOT TAKING THE SHORTEST WAY

Sometimes I worry that I will lose my sense of playfulness, that I will lose it somewhere on the road to becoming the best version of myself as a runner and ski alpinist. I reassure myself by recalling some of my many playful memories, for example at Grand Teton National Park in the United States.

Kilian (my partner in crime) and I were going for a run. We had looked at the map and seen a mountain a bit further away, but without any trail leading all the way to it; the trail ended at a big lake. On the other side, the mountain rose over the water. We decided to run off-trail through the forest. That was easier said than done. We were engulfed in big, jungle-like trees and bushes. The 2.5 mile approach took us more than three hours. But wow, it was so awesome! We had managed to come to Mount Moran, a mountain that few visitors have seen. The climb to the summit was fast. Curiosity and relief at running without having to jump over or under bushy branches made it easy, like a game.

On our way back we decided to swim. We rolled our cellphones in our t-shirts and tied them around our heads. Neither of us can brag about any impressive swimming skills. Kilian might even have doggy-paddled. We laughed until we choked. Our bundles became heavy, and it was strenuous with them atop our heads, but we calmly continued our swim. A mile of swimming felt almost as long as the entanglement in the jungle.

If ever I hesitate to deviate from what I have planned, memories like this make me leave the planned road in the end. ▲▲

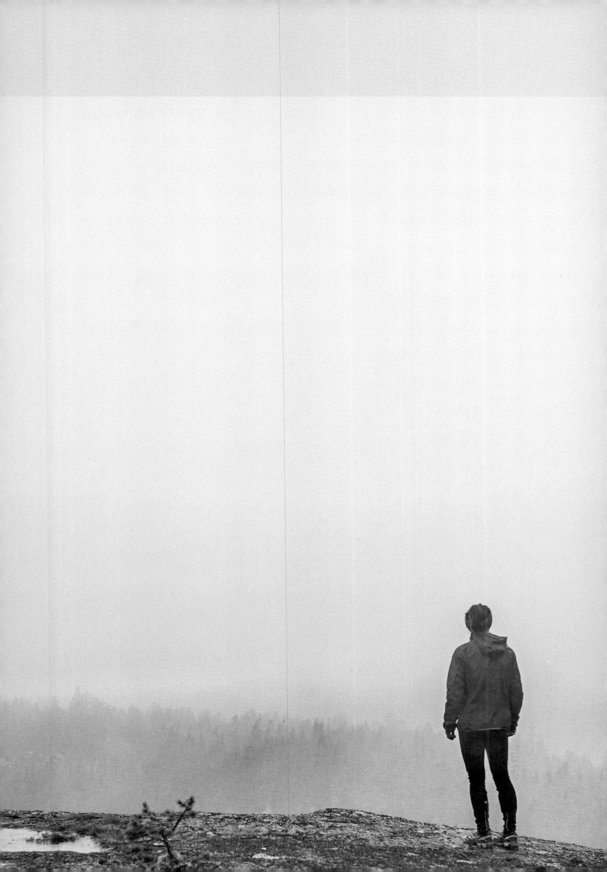

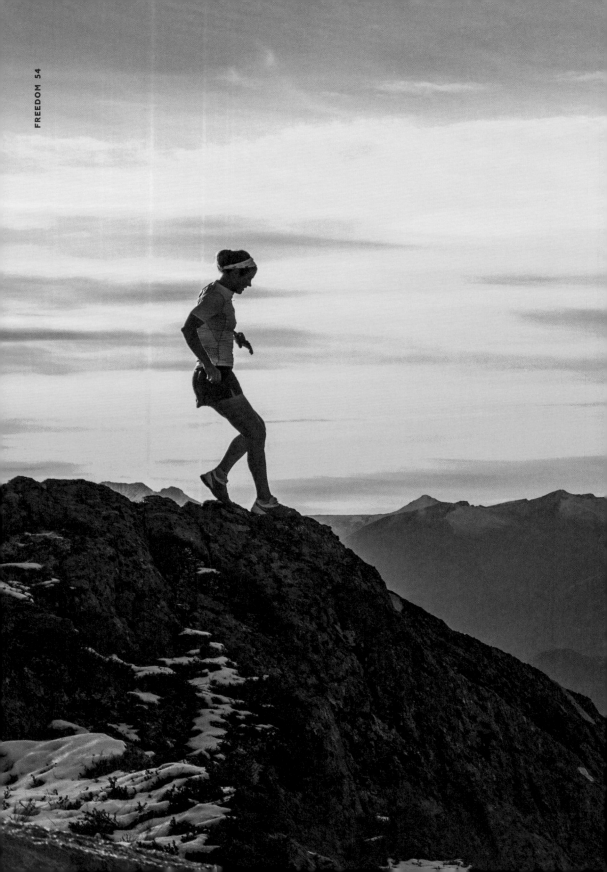

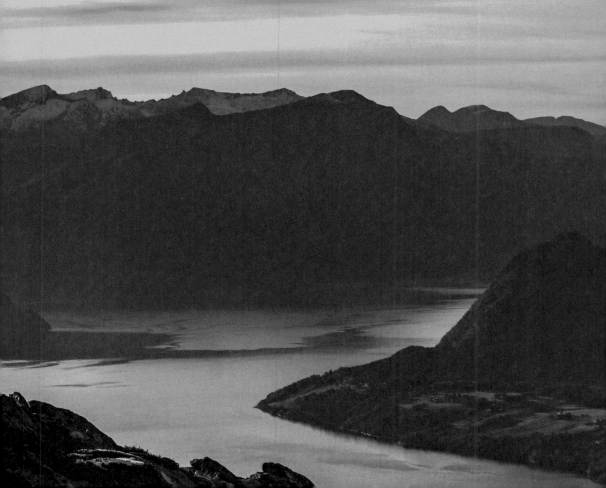

I RUN BECAUSE I WANT
TO RUN TOMORROW AS WELL—
NOT TO BE AS GOOD AS
POSSIBLE IN A CERTAIN RACE.

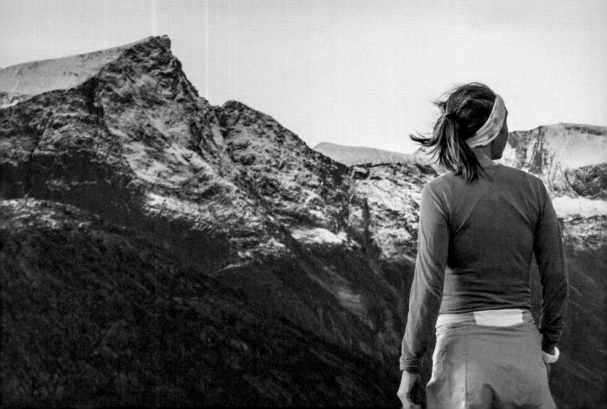

TAKING THE
GAME SERIOUSLY

I believe there is room for playfulness in most peoples' lives. As an elite athlete, I live for my own goals and work to get better, maybe even become the best. Therefore, I need to nurse my playfulness even more.

To me, playfulness is to be focused, wanting to perform at my very best, and to allow myself to live in a bubble, completely without distance from my sport. It is so real. And it is not only real, it is reality.

Paradoxically, playfulness to me is also to realize that not everything is deadly important, to keep a distance from things—from myself and from my training and racing, which is also my work—to see it all like a game. There and then the game is the only thing that matters; I do not think about the other reality at all, and that it is not even important in the long run.

Playfulness is something beautiful and very serious. That was always my approach to running: a simple, curious, and playful approach to the run. But I have still given my running one hundred percent, without thinking of things around me. If I manage to stay playful in what I do, then it feels like I have succeeded.

Without a playful approach to running, I would not be where I am today. I would not love running as much as I do. I like to sometimes run a small distance as fast as possible just for the fun of it, because it looks so nice. Or to take that little extra section just because of the excitement of it, or because of the view I think I will see when I get there.

If I were to focus on accomplishment only, to plan every training session in detail, to run every mile in a certain time, then I would not be successful in my training. My training simply has to be joyful, something I want to return to, not something I time to exactly one hour and just want to complete so I can wait for the next training session.

Some years ago, I felt that what I was doing was somehow not serious, just because I appreciated and individualized every training session. I felt that it would be more "real" if I meticulously followed a well-calculated plan; that somehow the freedom made it less serious. These are thoughts I had in the beginning of my career, but now I know that the freedom is more of a condition. I am open to changes in the training just to make it enjoyable.

We all have different motivations. My motivation has never been to become the greatest in my sport. My motivation has always been to appreciate my everyday life. And that always meant—especially the last few years—to maintain the freedom of my running. Only after fulfilling that, my motivation is to become the best possible version of me as an elite athlete.

Playfulness shows itself when I feel relaxed and safe, when I know what I am doing. In the summertime, running is number one, and I can play. I do my utmost, and I do it in the most enjoyable way possible, to appreciate and live to the fullest in what I do. To me, that's playing. ▲▲

— EXERCISES —

WHAT IS YOUR MOTIVATION?

Adjust your training to your goals—
and your prerequisites. And make it joyful!

I am a spontaneous person and I listen a lot to my body, so I do not plan all my training. Instead, I try to make an overall plan with a lot of flexibility in it. This means that I write down what key training sessions I would like to focus on for one particular week. The other sessions can be more impulsive. I try to do the key sessions when my body and mind are up for it, but spread out to avoid three hard training sessions in a row, of course.

KEY SESSIONS

Draw up a plan for the key sessions you want, and allow yourself to be more impulsive with the rest.

Calculate the ultimate amount of training you need for the distances you run. We all have different requirements, and depending on what your everyday life looks like in terms of work, family, and other duties, the same amount of training can be put together differently.

Just remember that it's during recovery that the body builds up. If your life is stressful, eight hours a week can be enough training to get in good shape for a marathon. If you have more time for training—and recovery!—you might reach 15 hours and get very good results.

FIND YOUR RIGHT LEVEL

To start, it is better to plan for fewer training hours than you have time and energy. Freedom is being able to choose, and in that way you give yourself the freedom to train according to the plan, or to train more. Make sure you do one to three key sessions a week; everything beyond that is just bonus training.

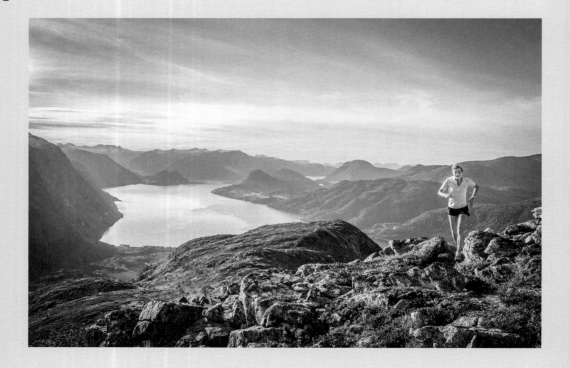

INTERVAL TRAINING

Fartlek is a Swedish expression used to describe longer intervals, where you play with different distances and speeds. I usually simulate the altitude profile and distance of a race, and adjust my training to that. I run the race course, but in miniature. As you are able to manage more, you can gradually scale up your training course.

FARTLEK 1

If I am going to run a mountain marathon with two steep climbs and a flat part at the end, I do a session with 2 x 20 minutes uphill, a slow descent, and then 20 minutes on the flat.

This could be done in all manner of ways, but to do it in relation to one particular race can be very rewarding.

FARTLEK 2

Another good session can be 15 minutes steep uphill, 10 minutes flat, 20 minutes slightly uphill, 10 minutes flat, with everything at competition speed. Hard but strengthening!

The trick is to see your training as something playful, something you want to return to, not something you have to do.

These sessions are brutal, so you don't have to do them every week—or even every month. If you do not have access to long slopes, it might be possible to do it if you get the chance, for example, during a mountain holiday.

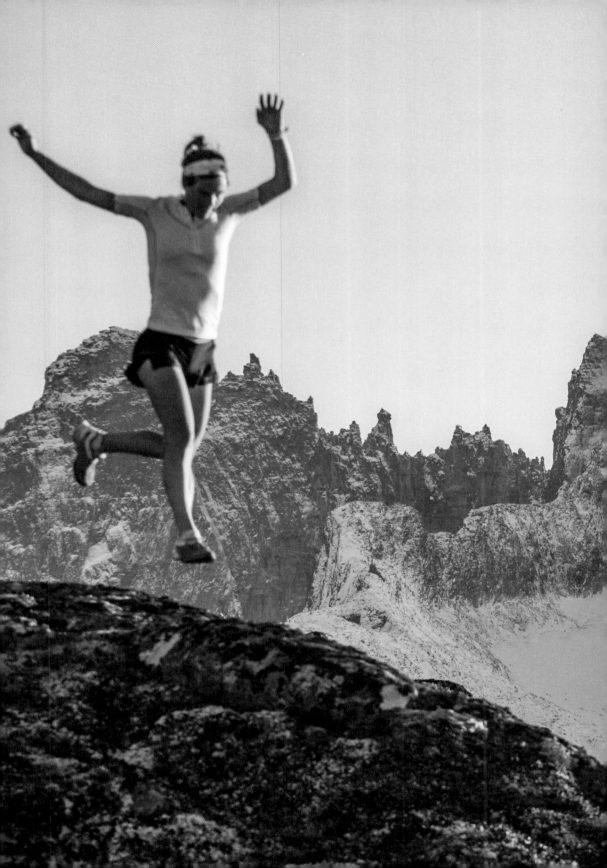

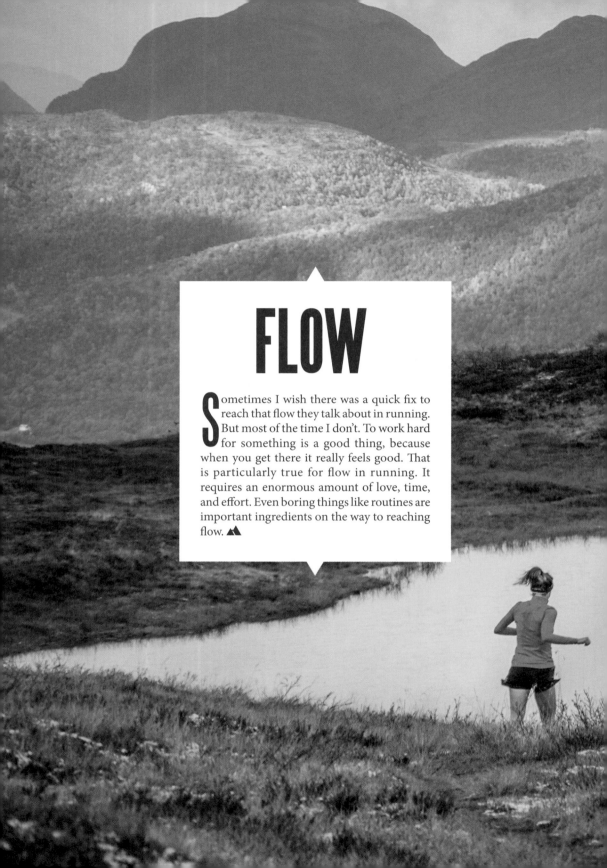

FLOW

Sometimes I wish there was a quick fix to reach that flow they talk about in running. But most of the time I don't. To work hard for something is a good thing, because when you get there it really feels good. That is particularly true for flow in running. It requires an enormous amount of love, time, and effort. Even boring things like routines are important ingredients on the way to reaching flow.

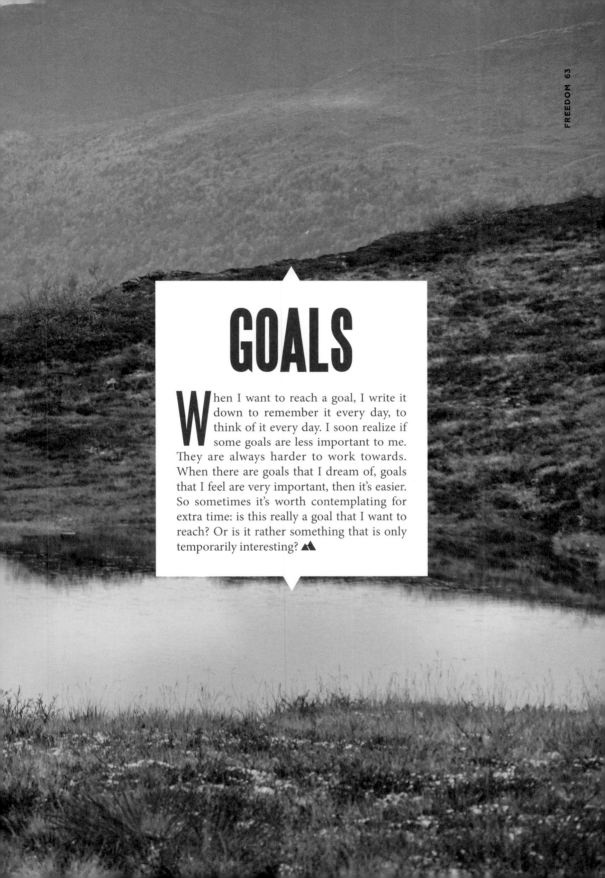

GOALS

When I want to reach a goal, I write it down to remember it every day, to think of it every day. I soon realize if some goals are less important to me. They are always harder to work towards. When there are goals that I dream of, goals that I feel are very important, then it's easier. So sometimes it's worth contemplating for extra time: is this really a goal that I want to reach? Or is it rather something that is only temporarily interesting? ▲▲

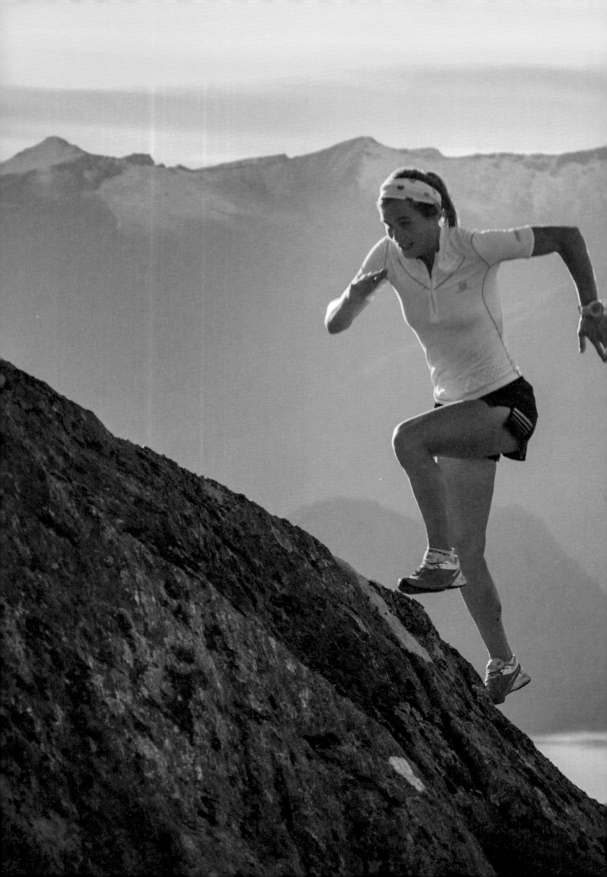

[UPHILL]

Meeting difficulties. About resistance,
invisible barriers, and how to make
the body work in harmony uphill.

[UPHILL]

In 2013, after my first year as a professional
athlete, I decided to try a 100-mile race.
100 miles is a legendary distance and a separate
discipline in the ultra and trail running world.
I signed up for *Diagonale des Fous,* a 105 mile
terrain race with 6.8 altitude miles;
13.7 miles up and down on the island of
La Réunion in the Indian Ocean. I wanted to see
what it felt like, how my body and mind would
react to such a challenge. I felt ready, safe in
the assurance that I would make it with a lot
of miles left in my legs, because I
love running! But there were some question
marks as well, like what happens when
you run for 25 hours?

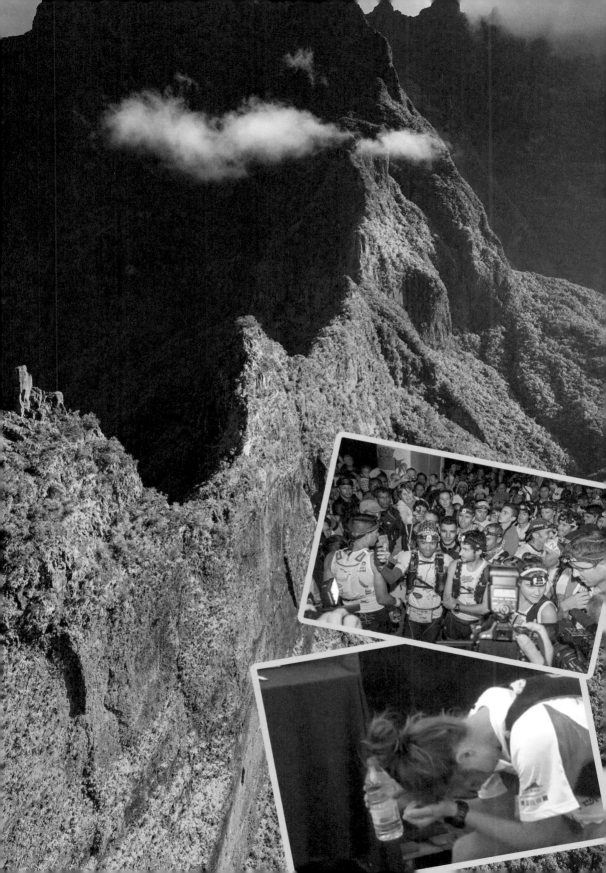

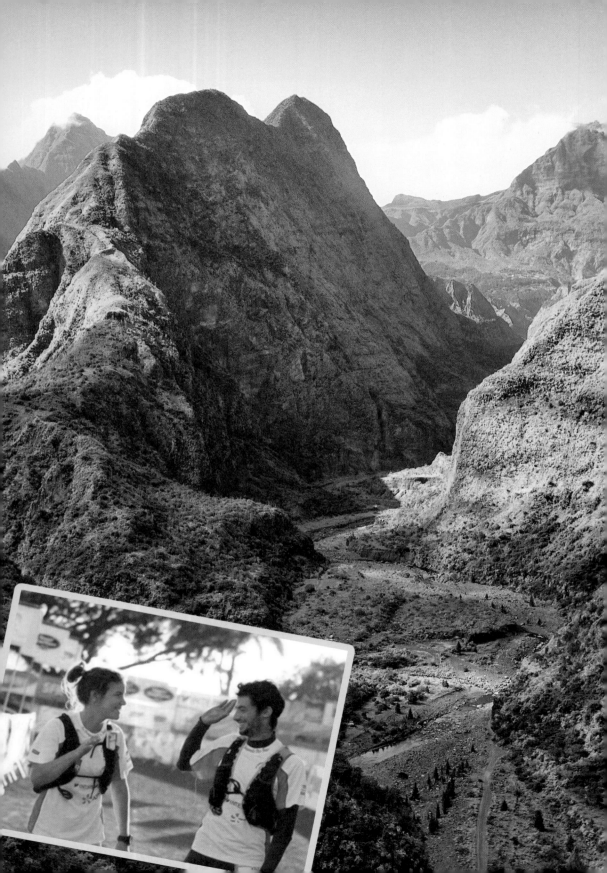

THE BARRIER

I learned a lot from that race, but the most important thing—and something I often return to—is what I learned about getting over barriers, those sky-high obstacles that can put an end to both thoughts and actions, those that are simply impossible to get over. That was what happened: I came to a barrier, and I did not even notice that it was a barrier because I could not see over it!

I was coming into the second night of the long race. I had been running for almost 20 hours, and I had decided to quit the race at the next aid station. I was completely convinced—as convinced as I was that my ski season would start two weeks later. I sat down and told the staff at the station that I was not continuing. Of course, they asked me if I was injured. Did I feel any pain? Or was I not able to eat?

Hm. I was not in pain, and I was not starving. Why did I want to quit, anyway? Because it was hard? Because I had already run six more hours than ever before? Because I had been awake for 48 hours and wanted to sleep? I had thought the decision through for miles and for several hours. I felt at ease with it. I simply did not want to run anymore. But when I looked from the outside and saw myself sitting there, eating properly and without any pain, I felt I couldn't quit. All the reasons that I had given myself before disappeared, like most things do if we give them some time and thought and step outside of ourselves. I think of barriers as thick fog: if you take a step toward that massive darkness, you realize that it's only air!

I got up and started to run again. The barrier that I had created in those previous few hours, the reasons I had to stop running, were gone with the wind.

It was so easy! That impassable obstacle that I had created in my head just disappeared! That seemingly insignificant incident has meant a lot to me. It has helped me to dare to challenge the limitations that our thoughts sometimes use to try to stop us. Could it be as easy as it was during that race? I bring this with me both in my training and in the rest of my life, but at the same time I also try to understand why that obstacle was created. Was it laziness? Or did the barrier hide something else, something more complex? Then I try to move on. ▲▲

I think of barriers as thick fog: if you take a step toward that massive darkness, you realize that it's only air!

THE POWER OF THOUGHT

We can control so many things with our thoughts. I believe that dark thoughts can be reversed. This is, of course, a good thing, but it can also become a burden. The knowledge that we possess power over our thoughts may risk it becoming an accomplishment in itself to ignore our own obstacles, which you should (and are expected to) handle. I believe that you have to meet your dark thoughts, too: think them through, process them, and learn something from them. Only in doing so can they become constructive, even instructive, something you take with you and remember later in life.

Did I really think it through? Digest it and overcome what I needed to? Or did I take the easiest way out and put the thoughts aside, in order to move on (too) quickly?

One example of this balancing act is when I am making decisions about my training. Do I need to rest, or am I just a bit lazy? Do I need to think more about this, or am I done with thinking about it and ready to move on? ▲▲

UPHILL
TRAINING

Do you know the feeling of standing on the summit, looking out over the landscape and contemplating the uphill climb that just took you there? I love that feeling! But usually you don't stay for very long at the summit. It's actually on the climb where you spend most of the time. The downhill is much faster!

It's definitely harder to run uphill. Therefore, I've always strived to make it as comfortable as possible—tried to find my drive, the ultimate and most efficient running stride uphill. As I love running in the mountains, I have tried to develop a nice feeling in my body during the part that takes the longest. As with most things, I think, the things I do a lot—the things that could take me to places where I want to be—I have to do what I can to make these things as good as possible.

The summer when I started to identify as a runner, in 2009, I worked in Turtagrø, Norway, in the reception at Turtagrø hotel. I mostly ran uphill. I felt that uphill running was a good way to build strength for running in a comfortable way, and I decided to trust that feeling. I wanted to train my body to be able to run every day. I enjoyed running so much that this became my only goal.

Turtagrø is at 3,000 feet above sea level, and sometimes I hitchhiked down to the fjord to run back. Other days I ran all the way up to the 4,600 foot tall Sognefjellet, 12.5 miles with a 4,600 foot climb.

Sometimes I feel the best flow when I run uphill, which might seem a bit contradictory when you think of how the word "uphill" is used symbolically in our everyday language. The term "flow" is not usually the first thing that comes to mind when one thinks about uphill running. I have thought a lot about why I still feel it is such a positive experience. Maybe it's because of the euphoria of getting into a state where the heavy breath and the grinding legs are in a perfect symbiosis. The perfect within the imperfect makes it great. Maybe it is the ability to focus on the simple part of something that is actually so complex.

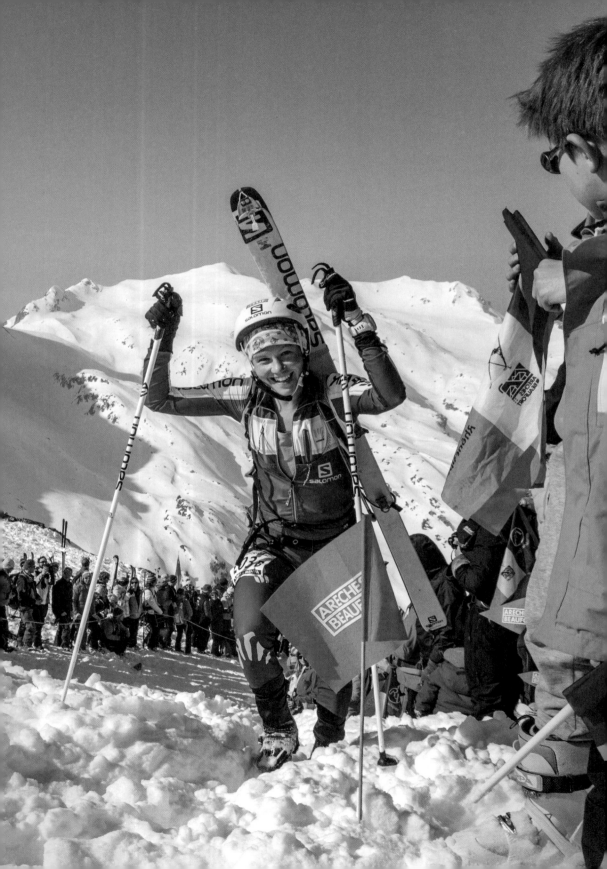

[UPHILL]

— LES MARECOTTES, SWITZERLAND, 2016 —

AT THE SUMMIT

Like an uphill flow. That's how my preseason felt before the 2016 ski mountaineering racing season. I had a perfect training schedule and had more than enough motivation and energy to follow it meticulously, even though I knew that some training days were going to be really hard. The weeks in November and December were like a long, slow, and completely wonderful uphill climb. The flow was there, albeit not all the time, but I knew it would always stubbornly show itself. I just had to continue working and it would come back sooner or later.

At the time of the first world cup race, I was in good shape. I felt I could stand on a tall mountain after a long uphill climb and still have very fresh legs. The first race was the individual, about 1 mile of altitude divided between four summits in about two hours. And I won! That was one of my greatest moments as an athlete. To win an individual race had felt so impossible. Ski mountaineering is a sport that the very best women have done nearly all their lives, and I still counted as a beginner. I always lost so many seconds on some of the technical parts where you needed the experience. A victory felt so far off.

The day after, it was time for the vertical, a discipline where you only ski uphill, most often about a half mile. I exceeded my own expectations here too, with a silver medal. Earlier a bronze medal felt more likely, as if that was the only realistic possibility in all disciplines. That start of the season made me believe I could perform well in the European Championship.

There is something special about getting closer to the summit. All the hours that I spent on training made it possible to get there, light and fast, with expectations and curiosity about what comes next. What will I see up there?

AND THEN DOWNHILL...

The European Championship came, and I was ready. First day and first uphill. It felt good; I pushed myself as sustainably as I could with the upcoming climbs in mind. In the first downhill, I was the second woman. The change before the second uphill was getting closer. In a maximum of 20 seconds, I would get out my climbing skins from a chest pocket, take off my skis and put the skins on. On my way to the change, I suddenly saw something flicker behind me. I felt a tug at the back end of my ski, and suddenly I was laying in the deep powder beside the track.

What had happened? A light touch from the person behind me had made me fall. Damn it. It was going to take a lot of time to get up from this, to get out on the flat trail again and to get to the change without the speed from the downhill. My chance of a good position was decreasing by the second. I tried to stop thinking about my lost seconds and focus on getting out of the powder hole.

Something was wrong with my knee. It felt strange. I did not know in which way, just that it was not okay.

I reached the flat area again before the change and was overtaken by yet another girl. Now I was fourth. Damn it! Focus!

The frustration over lost positions was severe. When I finally reached the change to turn back up again, I was fifth. My knee did not feel good. I deliberated with myself. My willpower was so strong; I really wanted to continue. I

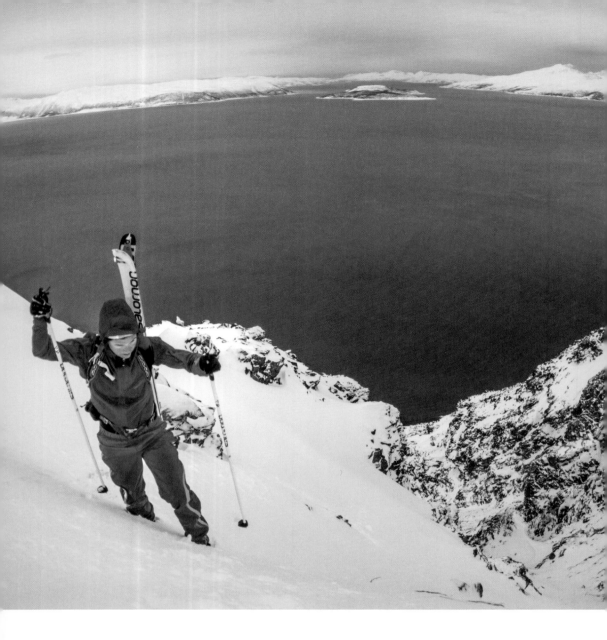

was in such good shape. But there and then, I actually thought about that promise I had made to myself to never risk my health and the most valuable thing I had in life: the ability to train every day. I just could not take that risk. I decided to quit the race.

HOPE

It was a hard decision. And what was waiting for me? What was wrong with my knee?

The race doctor had a look at it and thought it was pretty stable after all. The first diagnosis was that it might be a strained ligament—not a big deal. We still went to the hospital for an MRI.

There and then, I thought about that promise I had made to myself to never risk my health and the most valuable thing I had in life: the ability to train every day.

That hope. It can feel so nice and yet cause so much pain when it gets dashed. Three doctors examined my knee clinically, and they gave me hope. They agreed that my knee was too stable for it to be a rupture of the cruciate ligament. It was most likely a small rupture, or a strained ligament. I could probably be back on skis for the next world cup race. And what was the EC compared to winning the entire world cup? That was a nice goal. Maybe I could even do the vertical the next day?

The MRI result came in, and I limped to the doctor and his computer. He said nothing, just stared at the screen.

Oh, no.

"Not good..." "...the cruciate ligament..." "...full rupture..."

I didn't hear after that. Everything just disappeared. The cruciate ligament. That's a serious injury: nearly one year of rehab; several months without being able to move.

The evening after I received the results was so strange. As it was the EC, I was in Switzerland with the Swedish national ski mountaineering team. My teammates and friends would be skiing the vertical the next day.

My first intuition was to accept it and just move on. I knew what I had to do. In the one moment I was rational. I wrote a list of things I had to find out. I looked into different surgery options and tried to understand how they were implemented, and how to plan the months of rehab afterwards. How I was going to find things to occupy myself during the next few months?

All of those thoughts came at once. But that was only one side of me, of course. I was sad, but I knew I had to move on. I wanted to spend time with my teammates, to support them before the vertical the next day. The other side of me just wanted to hide in my room and wake up six months later with a healed knee.

AT THE BOTTOM

The next day I went home, and I lived the time that followed in a sort of haze. I had nothing left. My goals, my job, my passion, my everyday life—everything was gone. And with the loss came uncertainty, and so many questions. The first time you get injured is probably the worst; all questions and feelings are new. I did not know what a life without movement looked like.

In one sense I was angry. My whole training philosophy during the last ten years had been to stay injury-free, just because the greatest thing of all to me was to be able to run or ski every day if I felt like it. Now it had been taken away from me, and it was not even my own fault. That was hard to digest and difficult to accept!

THE TURNING POINT

After many phone calls and many studies of different surgery options, after many dark moments, hours, and days, I decided to have surgery on the cruciate ligament in Umeå, Sweden. That was 13 days after the accident.

That also ended up being the turning point.

I gave myself that deadline. By then, I would have gone through the worst thoughts, allowed myself to be down there at the deepest bottom of this dark mess. I wanted to be sad and downhearted. Because if I wasn't, what was it all worth, what was taken away from me? To me, it was worth everything in the whole world.

Although everything was as dark as the night, I somehow enjoyed allowing myself to be that downhearted. It sounds strange, but I could almost enjoy my self-pity, because I knew I could get out of that dark room, and that was the most important thing.

I also knew that although my entire world had fallen apart in one single moment, I still

I chose to accept a situation I didn't create myself. That gave me some peace.

had other things. I knew there was something, even if it was small. And even if I did not appreciate it before, it was there.

Some moments I felt guilty because I was so depressed about this mundane detail, an injured cruciate ligament—that's nothing compared to everything that happens around the world. But you cannot think like that all the time. In one way, it gave some distance to things and I could handle them better, look at them more objectively. But on the other hand, I could not belittle the thing that mattered the most to me. My love, my passion, and my work had been taken away from me in the blink of an eye.

Sometimes, when I was falling down into that dark hole and felt it was not sustainable any more, I forced my thoughts to my other leg, which I could stand on. There were other things that made my day brighter after all. My friends. My boyfriend. My family. My garden. My curiosity. Things besides running that always made me happy. They were there and I tried to focus on them.

FORWARDS

I would be lying if I said that things only went upward for me after the surgery. I had decided to look forward, be positive, and make the best of life as it was, but sometimes I just wanted to fall asleep and wake up and be up running in the mountains again. Sometimes when I looked out over the mountains, heard about friends and other people training, being outside, racing, doing everything I used to do, it was hard. When my longing for a quick run up a mountain—for the feeling of hard-working muscles in harmony with the breath—was too great, it almost physically hurt inside me.

I made a list of things I wanted to do during this period of time. Was there something I could develop? Learn more about? Things I did not have time for before?

Some days I would lie on the couch, feel sorry for myself, and watch a TV series. I excused those days with the thought that everything does not have to be that damn meaningful. There was surely a purpose in lying there in my bubble and getting tired of it. Maybe it was just coming to understand that there are better things to do in life than pity myself.

We have to find something that makes our everyday life meaningful. During the time I was injured, the rehab gave me my purpose in life. That was far from what I really wanted, but I knew it would take me there if I gave it time and patience.

I was almost always able to appreciate the time I had to prepare a large vegetable garden, weed the forest, chop wood, clear bushes, and do other projects and studies. But I often ended up thinking that this was not what I had chosen. I read some articles and self-help books, even saw a sports psychologist. It was rewarding, in particular, to see that the process I was going through was quite normal. To allow myself to fall, but be able to get up from the hole and look forward—that is the most important thing that I learned from these books and magazines, and from my own evaluations. That is how it worked for me.

But it was hard. I just wanted to run. I hadn't chosen to do other things than to run. I returned to that all the time—the freedom to choose. That is important. I knew that I just had to accept the situation and move on. I chose to accept a situation I didn't create myself. That gave me some peace.

Although my motivation to do these second-choice activities was low, I just did them. At the end of the day, it felt more meaningful than if I had done nothing. Focus on that! ▴▴

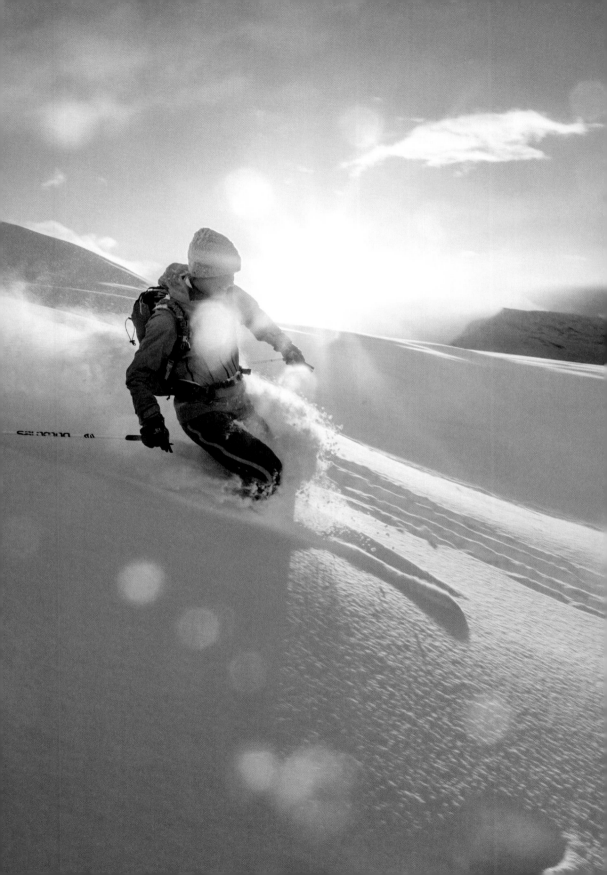

BEGINNING
FROM WITHIN

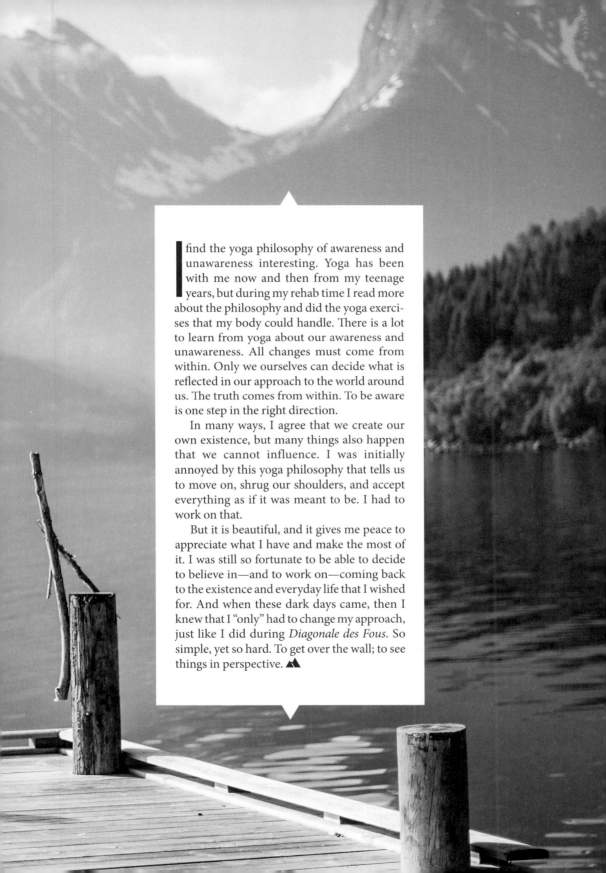

I find the yoga philosophy of awareness and unawareness interesting. Yoga has been with me now and then from my teenage years, but during my rehab time I read more about the philosophy and did the yoga exercises that my body could handle. There is a lot to learn from yoga about our awareness and unawareness. All changes must come from within. Only we ourselves can decide what is reflected in our approach to the world around us. The truth comes from within. To be aware is one step in the right direction.

In many ways, I agree that we create our own existence, but many things also happen that we cannot influence. I was initially annoyed by this yoga philosophy that tells us to move on, shrug our shoulders, and accept everything as if it was meant to be. I had to work on that.

But it is beautiful, and it gives me peace to appreciate what I have and make the most of it. I was still so fortunate to be able to decide to believe in—and to work on—coming back to the existence and everyday life that I wished for. And when these dark days came, then I knew that I "only" had to change my approach, just like I did during *Diagonale des Fous*. So simple, yet so hard. To get over the wall; to see things in perspective. ▲▲

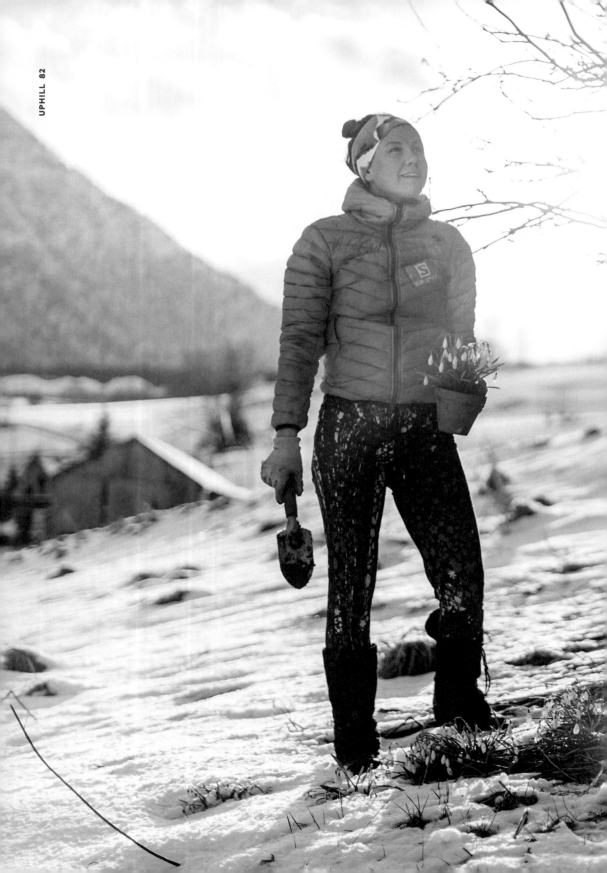

THE MEANINGFUL

There are a few things that I find interesting about my rehab period. Yes, it was interesting, but when people say, "I am convinced that you, in retrospect, appreciate your rehab time, that it gave you new perspectives and made you value what you do even more," I almost explode. I didn't have to get injured to realize how much I love running and skiing!

Well, the interesting thing that I did realize during this time is that even though I love what I do, it's important to have other things in life, other interests. It doesn't have to be something that takes a lot of time or that I do very actively. It could just exist, waiting for the day when I have more time to develop it. Just the thought of it now and then is enough. I even created my own Instagram account, Moon Valley Small Farming, where I could share my dream to live in a fully self-sufficient way. There I also followed others who lived or wanted to live in a sustainable way, in harmony with nature. It gave me some meaning when I could not run and became one leg that I knew I could steadily stand on anytime in the future.

To me, it was important to define what could make my everyday life more meaningful. I wanted to take the opportunity to learn more about farming. I also wanted to learn more about human anatomy. I basically made up a plan for how much time I would engage in self-study. I even set goals for what I wanted to learn every couple of weeks. And when I fell down into boredom because I could not run, then I at least had something to fall back on, something within reach just at the edge of that dark hole.

What helped me to get up from that muddy black hole can be compared to a long, horribly hard uphill climb. I had done it before: fought myself over the edge, put a lot of hours into it, got my legs to work on pure autopilot, shut down despite being aware. Just did it. Once back up, you can breathe again and enjoy the work you have done, and pat yourself on the back. Even if you only stay up there for a short time and fall down again, then you know that you have been up there, that you have worked your way there by your own means. You can do it again. It might be harder if the climb is longer. But it might also be easier. And it could flatten out so you can suddenly take longer steps, and leave the black hole behind. ▲▲

— EXERCISES —

UPHILL RUNNING

*Technique and intervals that make
a difference in my uphill running.*

Uphill intervals are the best! I love the feeling of being able to push myself to the max, as if the resistance is my friend!

And just like everything else, it's easier if you like what you are doing. It might seem a little odd to like uphill running—the hard and slow activity. But try! Do not give up! It's such a wonderful feeling when you nail it.

FIND THE RIGHT TECHNIQUE

Make it as comfortable as possible. There are different techniques that use different muscles for different angles. For example, when it's very steep:

→ Walk fast with large strides, where you push against your thighs with your hands and arms.

→ Shorter steps, more running, with higher frequency where you work more with the front muscles of your thighs.

Neither of these are faster than the other, but it's nice to switch between the two techniques to use different muscle groups.

MY APPROACH

When I train and grow tired, I always try to run with small strides, because when I am tired, that is what I find the hardest. I prefer the fast walking, and I want to train what I am less comfortable with.

The most efficient uphill technique is to keep your frequency with large steps, but it is also the hardest.

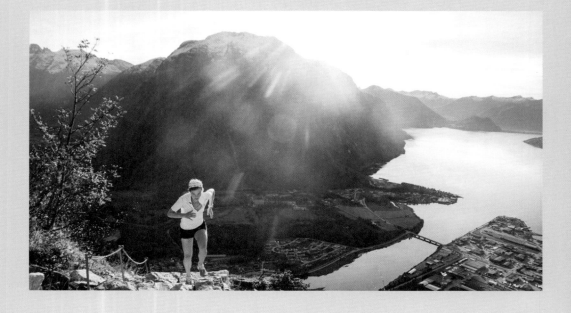

MY FAVORITE INTERVALS

I have a few favorite intervals that I find very useful for my uphill running and for my maximum oxygen uptake.

If the number of repetitions feels too many, just do fewer and look at my suggestions as goals. I did not start with that many repetitions, and you should start from your own level, too!

10 X 2 MINUTES WITH 1 MINUTE OF REST

This is one of the easier intervals; two minutes is quite manageable. I find this one good when I haven't done any intervals for a while and want to get started again, or if it's not long until a race and I want to decrease the amount of training. The feeling should be manageable the entire time. You can work close to the lactic threshold but do not pass it, and remember that you should be able to do 10 repetitions (or the amount that you decide to do)!

6 X 4 MINUTES WITH 1 MINUTE OF REST

Here you can work even further under the lactic threshold, but towards the end of the total number of repetitions you can allow yourself to get closer to it. Try to keep the same speed throughout all the repetitions.

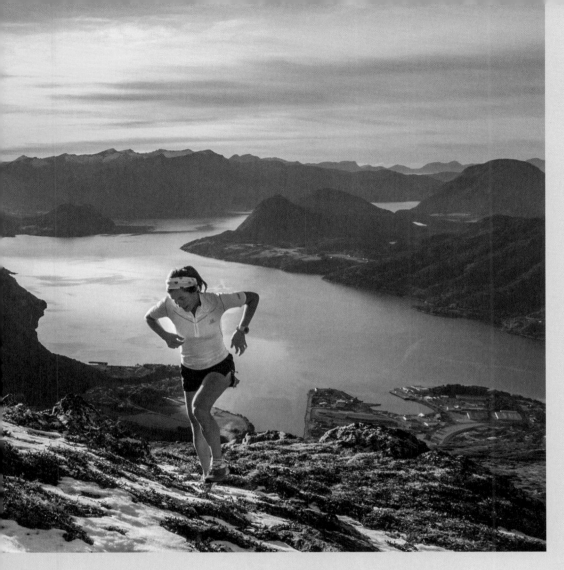

3 X 10 MINUTES WITH 2 MINUTES OF REST
Think competition speed here. These intervals are hard, but give you so much endurance and provide practice at a higher speed!

10 X 30 SECONDS WITH 30 SECONDS OF REST. REPEAT 3 TIMES WITH 2 MINUTES OF REST BETWEEN EACH BLOCK.
This is a very explosive exercise that can be very hard. It's interesting to mix some explosiveness into your cardio training to get a better general result.

It's better to start a bit slower, do fewer repetitions, and increase the number after awhile. It is much more fun to get a positive surprise, rather than never wanting to do the exercise again. Remember that everything over 12 minutes of high intensity running gives results, and work from there.

Just like everything else, it's easier if you like what you're doing.

CHAPTER 5

[CULTIVATION]

About love for the soil and the value
in letting important things take time.
And building long-term strength.

[CULTIVATION]

I like the word cultivation. Not only
in the sense of cultivating vegetables, plants,
and herbs, but because it can be a metaphor for
so much more. Cultivation makes me think
of nature, of food, and of the most important
thing there is: taking care of nature.
It also makes me think of cultivating an interest.
Letting things take time. Trying things out in
your own way. Year after year evaluating,
doing it again, and doing it better. Fastidiously
working onward.

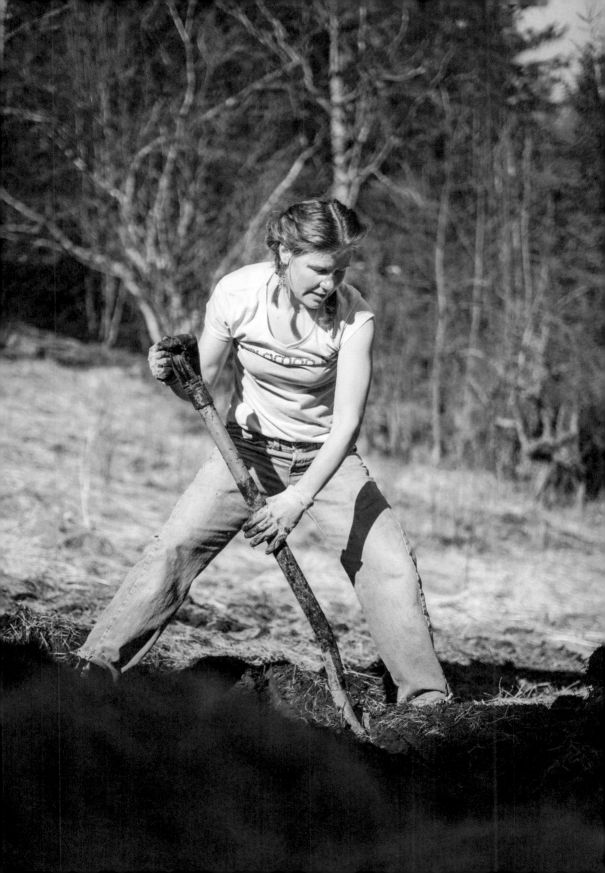

CHILDHOOD

Growing up, my sister and I spent a lot of time at our grandparents'. It was natural for us to harvest fresh potatoes for dinner and strawberries for dessert. These are strong memories, thinking about our grandparents.

My father's parents were farmers. They owned a forest and a barn. The barn was empty because the cattle had been sold, but the potato and vegetable gardens still flourished when we were kids. It was a simple life: outdoor work, lunch and dinner, and if there was time, watch some television in the evening.

I was 16 years old when my grandparents passed away. The big, white house with the red barn and the surrounding forest were for sale, and a small part of me started to dream of buying it—the part of me that dreamed of cultivating the soil, getting some animals, expanding the farm, just creating a living there.

By that time I was already thinking a lot about what you really need to be happy. I wanted to strive to be happy with the small things. I didn't want to feel that I had to buy new clothes to feel pretty, or to hang around with friends to feel popular. I did not want to be dependent on material things to find peace and happiness. I wanted to focus only on the essentials that help us put food on the table. I wanted to cultivate an interest from curiosity, to sow a seed and let it grow bigger and bigger, to plant a plant to care for and cultivate in all its stages. I wanted to cultivate a friendship—to water it, nurse it, and eventually make it flourish. To cultivate love.

All of this means taking care of something, something that is real. Something that makes it possible to live.

FINDING MY WAY BACK

For many years I traveled a lot. As I was changing homes and mountains every now and again, I had no opportunity to cultivate my own garden. However, I have always searched for and found opportunities to help out and be a part of cultivating with others.

Until I was 25 years old, I was mostly attracted to a life as a vagabond. I wanted change, to see new things, to explore the unknown, the things I liked so much. And I wanted to climb mountains. For several years I only worked shorter periods and explored some of the world's most well-known climbing areas in the time between. At the same time, I daydreamed of a future where I would begin to cultivate. The thoughts of that kind of life drove me onward and gave me a kind of stability in an otherwise roaming life. I knew where I wanted to be. I wanted to find my way back to those thoughts that I had as a 16-year old, when I almost settled down for good to cultivate at the High Coast.

Living off my sport and my sponsors is far away from the farmer's life I used to dream about. Instead it's about satisfying sponsors, testing materials and equipment, performing well in races, feeding social media, and being a familiar face. There's a lot of judgement involved. Luckily enough, I seldom get caught in the trap where I feel imprisoned by peoples' judgements of performance and results.

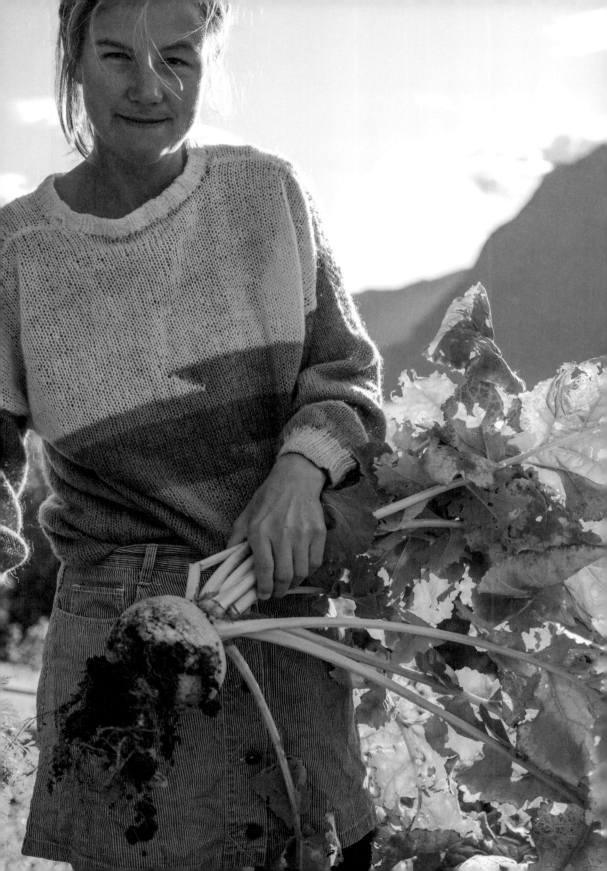

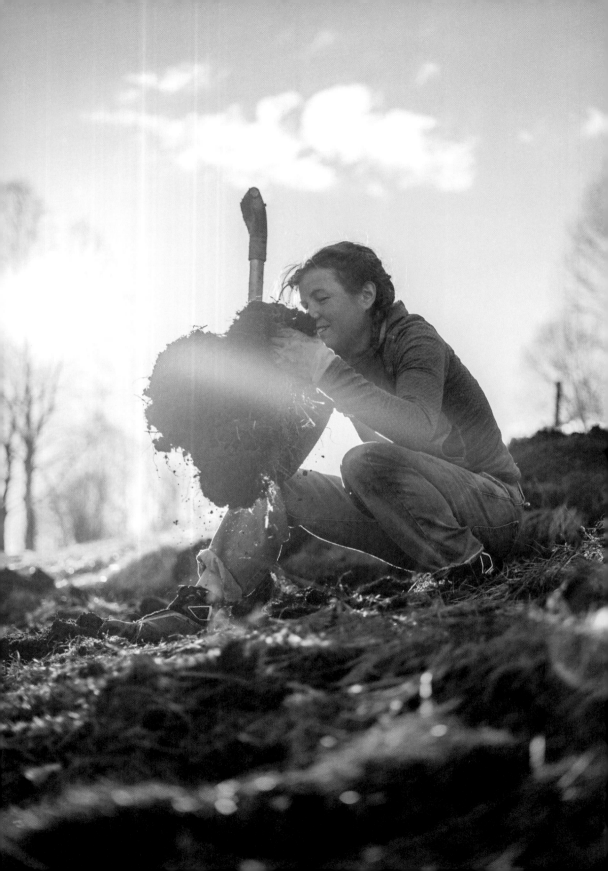

STEP ONE – TO DIG

After a year or so of racing and traveling with Tromsø in Northern Norway as my base, I decided to move to Chamonix, France, mainly in order to travel less.

We ended up in a small châlet 15 minutes outside Chamonix, an exclusive mecca for climbers and skiers, with a small vegetable garden in front of the house. Immediately, I thought of cultivation. With less time spent traveling, it would absolutely be possible to take care of a small vegetable garden. In the lower part of the garden, there was a small patch with less grass. "Perfect," I thought, and started digging.

There was a lot of gravel in the soil but I continued digging diligently. After God knows how many hours and developing a stiffness in my lower back, one of the neighbors stopped by. Despite my limited French, I managed to pick up that he was welcoming us to the village and that the place where I was digging was the place where some big machine put something in the wintertime. A snow plow, of course. That explained all the gravel. In other words, not the best space to place your garden. But shame on the one who gives up. I chose a new patch.

Everyone who has turned a piece of land into a garden knows that it takes time to remove roots, to shake the soil from the tufts, to go through the soil again to remove more roots and weed what might still be left. Not an easy task, and it took me several days. My poor runner's back was not made for this work. One of the farms in the village had cows and I went there to ask for some manure—another funny conversation in dubious French. Eventually, it was time to sow.

I wanted to cultivate everything! I planted ten small rows of different kinds—neither smart nor cheap. But the harvest was good. Maybe not as much as I thought, but it was a delight to cook with vegetables that grew just outside our door.

Wise from former experience, I planned differently the next year. My garden was a bit bigger, and I had fewer plants. With only a few square feet to dig, it wasn't quite as much work. I started some of the seeds indoors in advance. I was a step ahead compared to the previous year. And the harvest showed the progression, with more vegetables for less work.

Through cultivation, I got in contact with our neighbors in the village. We talked about our harvests and had a cup of coffee now and then. It was exciting to build a life outside the mountain runner world!

HURRY SLOWLY

After nearly three years in the Alps, both Kilian and I started to long for the wilder mountains of the north, with fewer tourists and ski lifts.

All we needed were mountains, so there were quite a few options to choose from. We thought of Alaska, the Pyrenees, Norway, Sweden, and Italy. The most sensible option was Norway: close to Sweden and the mountains are amazing. As we both used to live in Norway, the area of Romsdalen felt like a good choice. In the spring of 2016, between my knee surgery and some of Kilian's races, we moved.

Because I had just had my surgery, I immediately parked myself on the couch in front of the window to the garden, with a notebook in my hand. I started to make plans for the summer. Here I could cultivate as much as I wanted! I had enough time to prepare, and the entire summer to take care of everything. I dreamed big, but my earlier experience had taught me to start on a small scale. It's easier to manage the small steps and continue building from there. Of course, it takes more time—maybe several years—but gathering knowledge and adding to my previous experience is the method that suits me best. I could have asked our neighbors to plow some fields for us, but I held myself back. It's nice to dream and fantasize big, but you need to start somewhere. And above all, complete your plans.

Cultivation and forestry gave me peace during the hard period when I was injured. I still don't know where this interest might take me. Maybe I will become a full-time farmer one day; maybe I will continue to cultivate for my own household and well-being only. I do know that every second of my work with the soil takes me somewhere I want to be. ▲▲

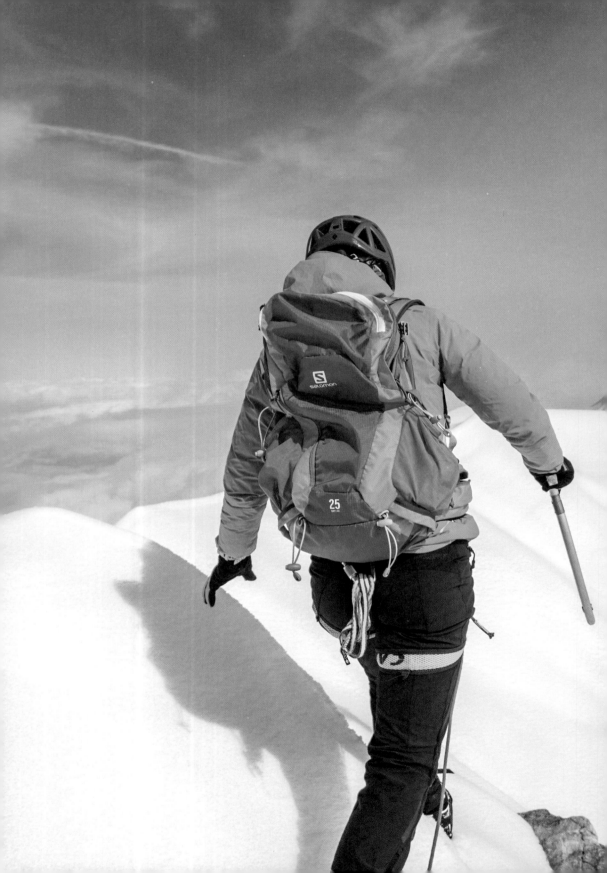

PERFORMANCE

Our performance is something that we ultimately decide for ourselves. It may seem like demands come from the outside, but almost always they come from our own thoughts and decisions about what we should be able to handle. We should all be nicer to ourselves, as only we ourselves know what baggage we carry with us.

From my first sponsor contract, I had already thought it through: what my framework looks like, what I stood for. It was always important to me to tell my sponsors what I wanted, and to tell them about my philosophy: that the greatest thing to me is not winning, that competition as my only goal just would not do. My condition for being able to live in this competitive world is that I manage to keep my love for mountains, running, and skiing. This means, for example, that I say no if a race or event does not comply with my values. There are always new races, new seasons.

To train to become the best version of yourself, to be as good as possible in the sports that you love (depending on your personal requirements), isn't that a kind of cultivation? It may seem far-fetched, but to me they have several things in common. Patience. Devotion. Always being there to take care of what you have sown, because if you miss some weeks or months, then you have a lot of work to catch up on. The harvest might be smaller, or maybe even destroyed. Or, it may recover anyway due to your careful preparations. ▲▲

I AM SUCH A MORNING PERSON—ALL ENERGY TO FACE THE DAY AHEAD OF ME!

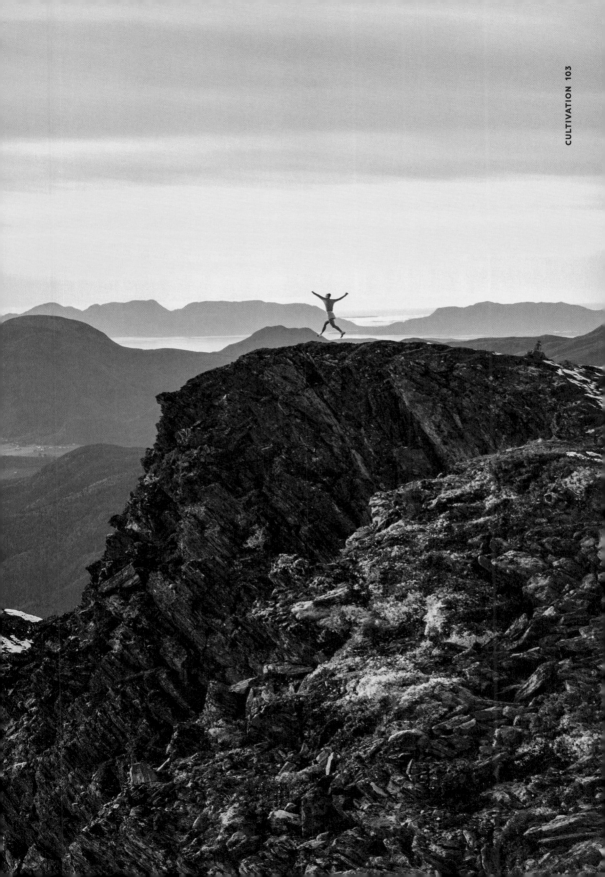

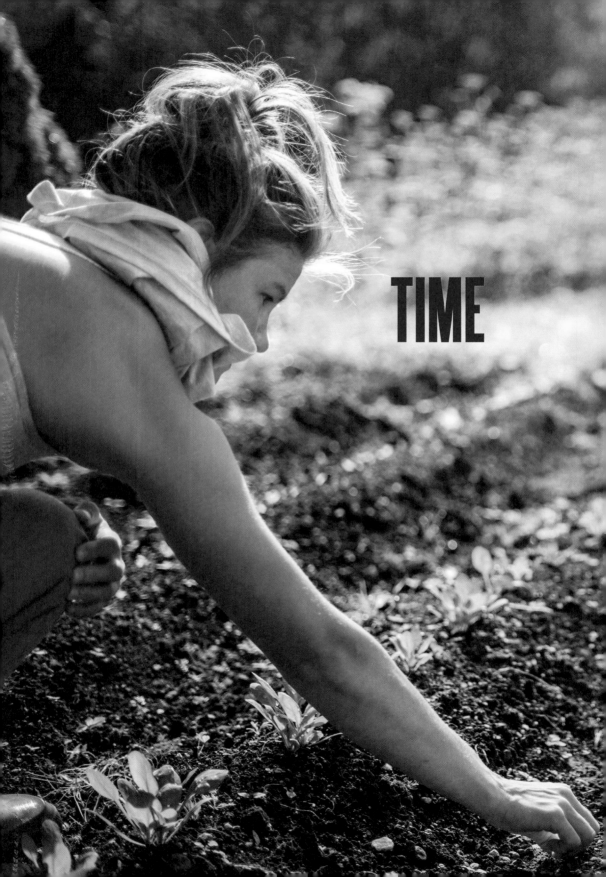

TIME

Time is among the most beautiful things you can give to someone. Cultivation is very much about putting time in, being patient, not rushing.

One way to find out if you're doing the right thing is to pause for a moment. If there is nothing else you would like to do there and then, nowhere else you would like to be than where you are, then it's right. That is the feeling I have when I work in my garden. It just feels right. The same feeling as when you miss the train, but it's alright because all your friends are there at the station. It doesn't matter if you miss something because you are together with the people you like the most.

We have our goals, but that's not where we spend most of our time. Rather, it's on the way. It's all the training hours where you spend the most time.

Ultrarunning requires cultivation. I believe it's important to build up your body over several years and in small steps so that joints and muscles adapt to running far and for a long time. Make it sustainable.

The human body is very adaptable, if you take it at the pace that the body requires. There is a difference between starting from zero and deciding to run ultra distance, and coming from another sport or hobby where you al-ready did a lot of training. The preparation differs, of course.

I started running longer distances a few years before I ran my first ultra race, which I believe was good for preventing injuries. I had many opportunities to get to know myself on long runs, but without time pressure. I needed hundreds of miles in my legs before I felt ready to do an ultra. The summer at Turtagrø, when my running reached a peak, my only goal was to be able to run every day if I wanted. I wanted to build up my body slowly. I never pushed myself. I always listened to my body, to every muscle and how they felt, whether I needed to rest. I had no goal to stress about and push toward, no race to be in good shape for.

When I felt comfortable with the base I had, when I felt that my body could handle it, I tested my limits in races, running for as long as 31 hours. And I felt so good afterwards!

My devotion and what makes me carry on may have changed, like most things do, but the core, the love, is still there. My goal has always been (and it's my job now) to take care of the desire that I have to move a lot—preferably every day, maybe several times a day. And I have made that into one of the finest feelings I have. ▲▲

— EXERCISES —

WANTING TO COME BACK

Get going, improve, and build your long-term strength.

My training journey started when I began to take notes about my running sessions. That is a good first step to get an overview of your weekly and monthly levels of running. Note down miles and hours. Hurry slowly. Look at your weekly miles and altitude feet, and increase it by between 5 and 15 percent the next week.

FIND YOUR MOTIVATION

What makes you come back to running week after week? It could be a race, sometimes just a feeling, or something else. Find it! What made you run to begin with may have changed over time; listen to yourself and adjust your training according to the new circumstances.

ENDURANCE SESSION 1

My favorite training is to take a few days off and go to the mountains. I bring a small backpack with some extra clothes, energy for the day, and a credit card. Then I run. Sweden has a fantastic network of mountain huts with perfect distances in between. Here you move pretty slowly, on soft ground, and for quite some time. To run between huts is a gentle way to build up endurance.

ENDURANCE SESSION 2

Another way to build up your endurance is to do double sessions. If it's winter and you are skiing, you could do one or several hours on skis first, then switch to running shoes and run for an hour. The body is already tired, but you end up using different muscles. The training is gentle as your body is tired, but not from running, so your running muscles are still fresh.

ALTERNATE YOUR TRAINING

If you don't feel like running for a couple of days, don't. Do something else instead: yoga, aerobics, dance, ice skating, cycling, boxing —the list is endless!

GET GOING AFTER THE WINTER

After the winter season, I start by jogging 3 miles for a couple of days, and then 6 miles. I usually take an extra rest day every week to get my body used to running instead of skiing. If you change or increase your training, it is even more important to take some time to listen to your body. The same is true when recovering from injury. The summer after my knee surgery, I expected the transition between skiing and running to be the same, but I felt at once that I couldn't start running as much as usual. I had to take a step back, run fewer miles, do rehab exercises, and take additional rest days.

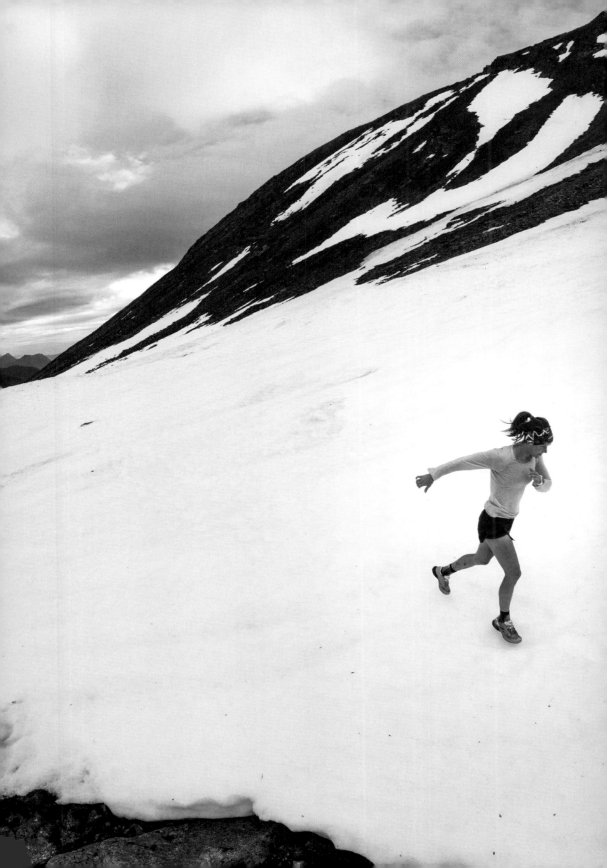

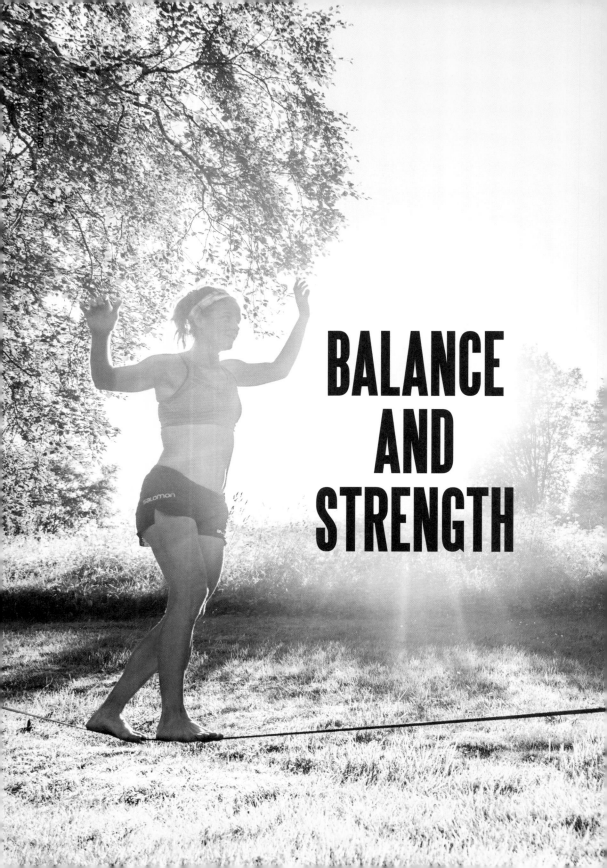

BALANCE AND STRENGTH

Before I realized that I was a runner, I had focused on climbing for several years. Many years after I quit climbing regularly and was only doing it a couple of times a year, my body felt balanced and strong and I had great body control. I would notice if my upper body sagged, my hips felt weak, and my core needed more strength.

During my student years in Umeå, I was good at maintaining my upper body strength, and at the same time, I ran quite a lot. In wintertime, there was more cross country skiing, which naturally meant less running. Because life as a student was relatively flexible, I could do about 12-15 training hours a week.

Most often, I was running in the morning. In the afternoon, I would do power yoga (vinyasa), strength training, or go for a second run. I generally trained twice a day, with one day of rest a week. Since the terrain in Umeå is very flat, I did my uphill intervals on the only hill there is, Bräntberget, with its 40 altitude meters. It might not sound like a lot, but running it 20 times is actually very strengthening!

When I became a full-time mountain athlete in 2013, I went all-in with running during the summer. I had not yet started ski mountaineering, so there was a lot of running from March to November. Even during the winter months, I was running on the side of cross country skiing and ski touring.

It sounds strange, but during these years I felt that I lost strength, that my running stride would sometimes give, that my upper body was not as strong as before. Especially when running downhill, it's important to be able to keep your upper body upright and in a good position, otherwise it is hard on the lower back. It had worked for two years thanks to my past as a climber, but after that it declined. It was not too serious, but I felt tired where I was never tired before, like in my feet, lower back, and hips.

Whatever it is, I believe you have to train hard at what you want to improve, but you also need general strength to be able to train that much. You need to find your own balance between alternative training, strength training, and running, depending on what your everyday life looks like and the background you have. ▲▲

— **EXERCISES: STRENGTH AND BALANCE** —

MAINTAINING YOUR STRENGTH

Preventing injuries with a few simple exercises.

It can be hard to find motivation to strength train at home after a run, but try to make it a routine. My motivation is that it prevents injuries. In running—especially downhill—you use many small muscles to keep a good posture, and it's important that these are strong. These simple exercises build up the small muscles, which are easy to neglect, but which need to be strong to make the body work optimally when running, to stay injury-free, to handle the level of training, and be in good general shape.

To motivate myself, I usually decide on only five of the exercises below. I do each one for 1 minute, and repeat 3 times. It doesn't feel like much, 15 minutes. Sometimes I do all of the exercises 3 times.

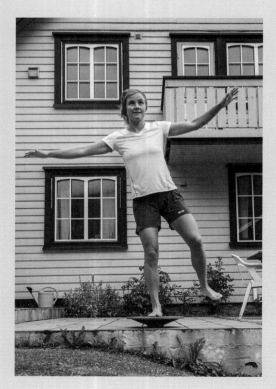

BALANCE EXERCISE
On the plate, you open up your hip and work with your balance. Stand on the plate with one leg, and then open up your hip. This is good for the small muscles in your feet and ankles.

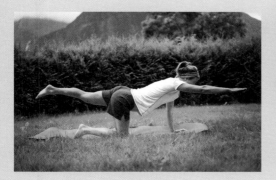

FOUR-LEGGED BALANCE

This is another seemingly simple exercise to work the small muscles to find balance.

Stand on hands and knees and stretch your right arm and left leg outwards. Alternate legs and arms. Remember to keep your hip bones parallel! If you need to, use a mirror to check to make sure you're doing it right.

THE SCISSORS

Lie on your back, lift your legs straight up, and lower them slowly towards the ground. Stop a few inches above the ground, and move your legs like scissors across each other for 30-60 seconds. Remember that your lower back should stay on the ground.

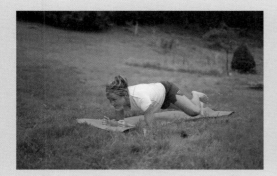

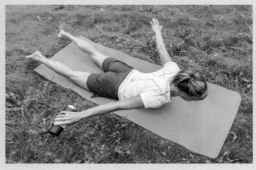

PLANK WITH LEG MOVEMENT

This is an optimal exercise as you build strength in a correct position and work to hold up your pelvis and back.

Start in plank position: toes and elbows or hands (high plank) on the ground. Bring your right knee towards your right arm, and then your left knee towards your left arm. Work your core stability with parallel hips. If you start arching your back, stop and have a rest.

SWIM WITH WATER BOTTLE

As a runner, you can easily neglect your back. I run downhill a lot. During the ski season, there is also a lot of forward movement. It's extra important to try to strengthen my back during the summer to counteract the forward bends during the winter. Here, you use your lower back as well as your shoulders and arms. Use a weight or a water bottle.

Lie on your belly with straight legs. Lift your upper body and "swim" with the bottle in one hand. Swap hands after half the time.

Whatever you do, you have to train a lot to get better at it, and general strength is essential to be able to train that much.

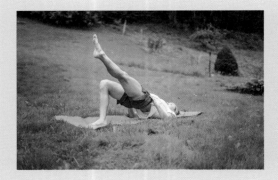

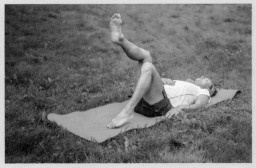

HIP STABILITY WITH LEG MOVEMENT

Although this exercise is relatively easy to do, it strengthens your small, inner abdominal muscles, your hip muscles, and the backside of your thighs and buttocks.

Lie on your back and pull your heels towards your buttock. Push up your body with your feet on the ground and hips parallel. Work with one leg at a time, first outwards then upwards. You can easily tell if your hips drop, or if one side is stronger than the other.

TOE DIP

Here, you use the small, inner abdominal muscles. This exercise is a good relief, as it is not very strenuous but still does a lot of good.

Lie on your back with your legs straight up in the air. Dip your toes towards the floor, keeping your legs straight. Remember to always keep your lower back on the ground.

TRICEPS PRESS AND PUSH UP

I sometimes do this exercise with winter on my mind, and with a desire to be a bit more strong all-around.

Lie on your belly, put hands and toes on the floor, and push up with a straight back.

CHAPTER 6

[NATURAL]

Natural energy for a natural life.
About finding balance in what we eat
to give the body energy, and recipes
for the food I like the most.

— TROMSØ 2013 —

The summit of Hamperokken seemed about 15 minutes away, but the technical ridge leading there never seemed to end. It was too steep, too narrow. I had to go down and around, and then back up again. Finally, I was there at the summit, after a long climb. I intentionally didn't bring any energy; a four-hour run without anything to eat is usually no problem. I can even imagine that it's sometimes good to run out of energy, to teach the body to go on anyway. One foot in front of the other. But this time it was harder; I could barely take another step. I must have been really tired. The only thing I could think of was the lunch that I was going to have at home. Beetroot soup!

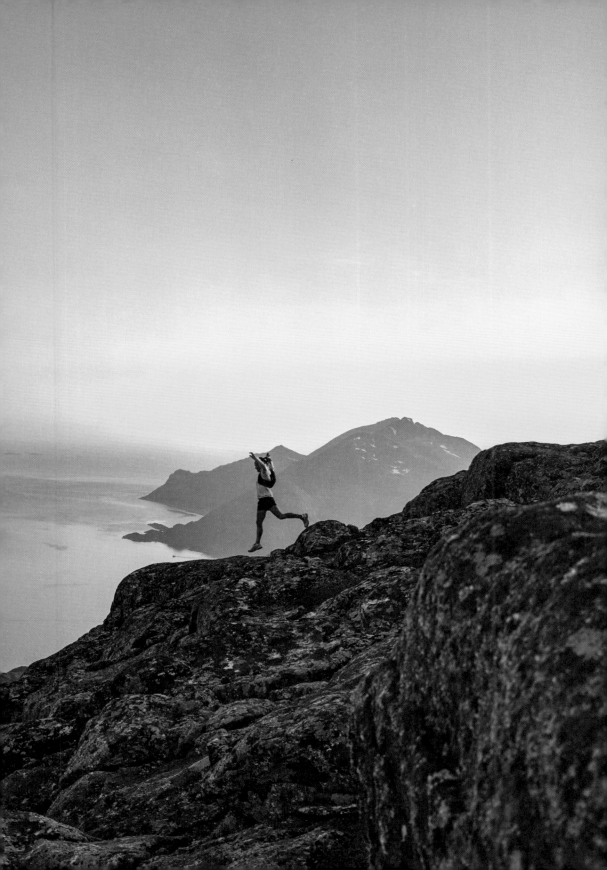

ENERGY

Beetroot soup. I had more to eat than that, but the thought of having a tasty soup and bread with lots of cheese made me continue running, step by step, all the way to the door of my house.

When you train many hours a week, food is an essential part of it. If you don't eat properly, you don't get enough energy to train. Of course, your body can get used to fewer calories, but that concept is not for me. I need lots of food to feel strong. And something sweet afterwards is good for my soul.

My philosophy is to eat a lot of greens, preferably things I cultivated myself, or at least locally produced and seasonally-based. I prefer a vegetarian diet, with a lot of carbohydrates like quinoa, wheat berries, potatoes, beets, pasta, and rice.

Through life I have eaten meat and fish every now and then, but for the last few years I have been vegetarian. One part of me likes the thought of walking down to the fjord and catching a fish, but after my journey to India and my time in a yoga school there, another part of me doesn't want to eat any other beings. It becomes important to listen, I think. I am convinced that if you only listen to what your body wants—or doesn't want—you feel better and grow stronger, which probably has a positive effect on your running as well. Sometimes I might only want to eat broccoli (and serious amounts of it), and I usually try to satisfy these cravings, especially when it's for a certain vegetable. I mix it with other kinds of basic food to get more calories, of course.

If something feels good I believe in it, regardless of whether it's scientifically proven. Human beings are intelligent animals, and we may know more than what science shows. This is another example of contrasts: my interest in research and science goes hand-in-hand with an appreciation for intuition and gut feeling!

SWEET CRAVINGS

Like many other people, I have a big weakness for sweets. I love desserts—and pastries and biscuits and buns and chocolate. As long as I am active and move a lot, I believe that one dessert a day is good for me. I do not feel those sweet cravings as often during weeks when I train less; this is probably connected to my total energy consumption. But if I stress a lot with computer work, sponsors or interviews, I can easily go for some sweet kicks, which I try to stay on top of.

In general, I try to focus on good food and the energy it gives me, and I believe the experience of eating is important. I do not think of food in relation to weight gain. As an elite athlete, I am aware of my body and how it can and should preform. For that reason, I focus on the performance. I want my body to perform for a long time. I want to be healthy, and to be able to run my entire life. Therefore, I do not believe in depriving myself of calories.

To compare and be compared to others is an aspect of sport. "How could she perform so well? What did she do that I didn't? How does she train and eat?" But when these thoughts come, I try to refocus on myself, on what I do and what my body needs to perform its best. And that is not to lose two or three pounds, because deep down inside I know that those additional pounds keep me strong and injury-free. It's just about training harder, and that's only possible if I eat well.

I sometimes think of Nero, the dog I had as a teenager. He felt good when he was able to run as far and as fast as he could manage. The bonus was when he came home and it is was feeding time. Then he was happy, almost like a real runner. ▲▲

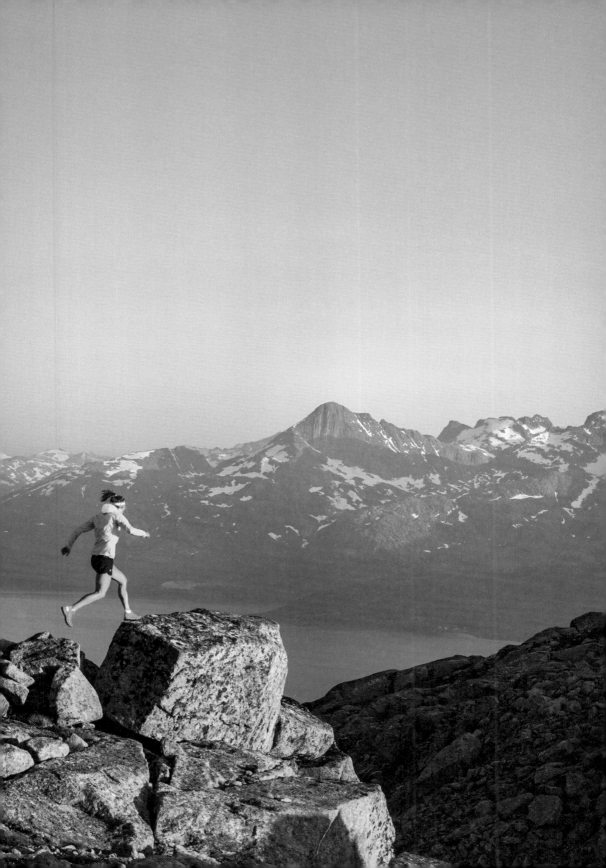

THE NATURAL MOVEMENT

One of the best things I know is to travel by my own means. I did my very first long transport run while I was still a passionate climber. I worked in a mountain lodge in Saltoluokta, in a landscape without roads, about 62 miles from Jokkmokk, Sweden. My neighbors were the world heritage sites Laponia and Sarek, with their tall, vast summits.

Maybe it was the lack of activity on my days off, or maybe it was because I always had the approach "Why walk when you can run?" But one day, I just packed a backpack with some extra clothes, a credit card, and some food, and then I ran over a beautiful open plateau between Saltoluokta and Sitojaure, with tundra and thin, stubborn mountain birches, to the next mountain hut. As I arrived at the hut, I left my pack and went up to Skierfe, a distinctive summit close by. The day after, I ran to the entrance of the Rapa Valley before I turned back to Saltoluokta to work again.

I remember feeling so rich: I could do something that beautiful, all alone in the mountains, moving lightly and quickly through a large part of my surroundings. Although I had never done it before, it felt like a natural part of life. It's a fantastic feeling to move this way from a to b, to work, to school, or to the grocery store. It feels like the human body is created for this kind of transport. We have been running since ancient times; maybe that is one of the abilities that has brought us to where we are today? We could chase animals to fatigue and find new foods by transporting ourselves over vast areas.

And today, even if we do not depend on running in the same way, I believe that running is an important part inside of us, and that it's good for us to let it thrive. We are born to run, each and every one of us. Running is the body's natural way of transporting us more quickly. We just need to find our own way based on our own requirements. ▲▲

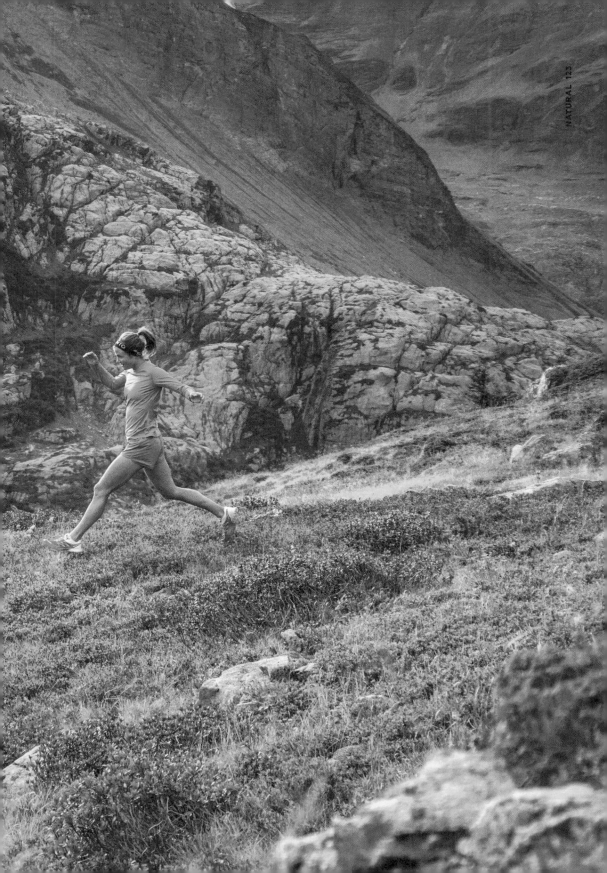

FOOD

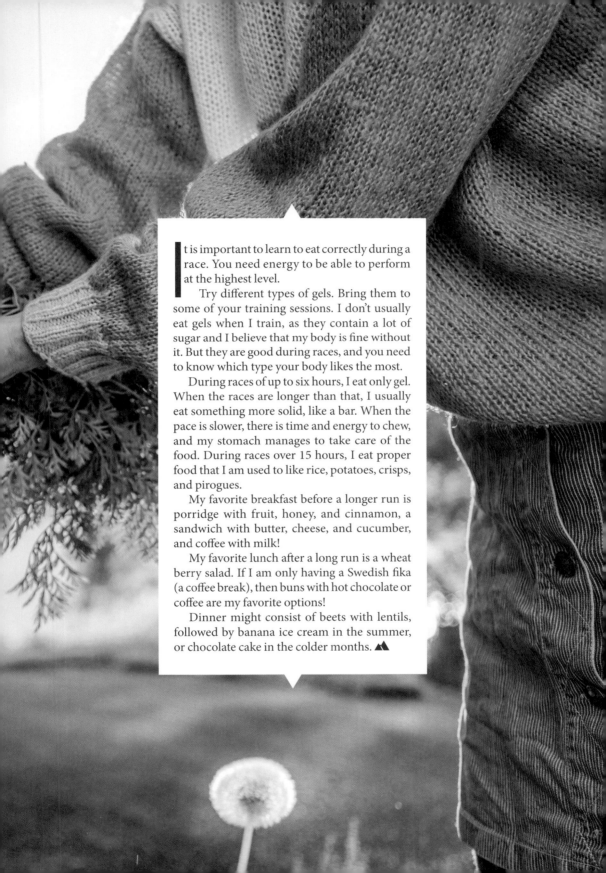

It is important to learn to eat correctly during a race. You need energy to be able to perform at the highest level.

Try different types of gels. Bring them to some of your training sessions. I don't usually eat gels when I train, as they contain a lot of sugar and I believe that my body is fine without it. But they are good during races, and you need to know which type your body likes the most.

During races of up to six hours, I eat only gel. When the races are longer than that, I usually eat something more solid, like a bar. When the pace is slower, there is time and energy to chew, and my stomach manages to take care of the food. During races over 15 hours, I eat proper food that I am used to like rice, potatoes, crisps, and pirogues.

My favorite breakfast before a longer run is porridge with fruit, honey, and cinnamon, a sandwich with butter, cheese, and cucumber, and coffee with milk!

My favorite lunch after a long run is a wheat berry salad. If I am only having a Swedish fika (a coffee break), then buns with hot chocolate or coffee are my favorite options!

Dinner might consist of beets with lentils, followed by banana ice cream in the summer, or chocolate cake in the colder months. ⛰

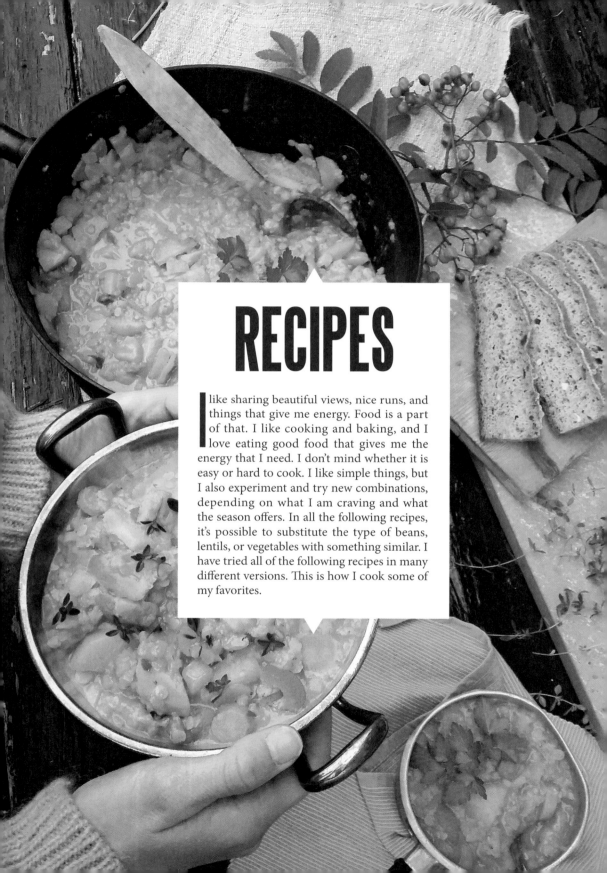

RECICES

I like sharing beautiful views, nice runs, and things that give me energy. Food is a part of that. I like cooking and baking, and I love eating good food that gives me the energy that I need. I don't mind whether it is easy or hard to cook. I like simple things, but I also experiment and try new combinations, depending on what I am craving and what the season offers. In all the following recipes, it's possible to substitute the type of beans, lentils, or vegetables with something similar. I have tried all of the following recipes in many different versions. This is how I cook some of my favorites.

BUCKWHEAT, QUINOA, OR WHEAT BERRY SALAD

4 SERVINGS

1 cup buckwheat, quinoa, or
 wheat berries
vegetable stock (optional)
½ cup broccoli
½ cup cauliflower
¼ bell pepper
¼ onion, preferably fresh
¾ cup cooked black beans
fresh herbs (optional)

DRESSING
2 tbsp olive oil
3 tbsp balsamic vinegar
1 tbsp dijon mustard
1 tsp salt

Cook the grains as recommended on the
package, preferably in vegetable stock.

Chop the vegetables to desired size (I
like them a bit smaller). Finely chop the
onion.

Mix the vegetables with the grains and
beans.

Mix the dressing and add it to the salad.
Top with fresh herbs, if you prefer.

LENTIL STEW

4-6 SERVINGS

1 ¼ cup red lentils
1-2 tbsp oil
1 onion
1 carrot
1 potato
½ zucchini
1 ¾ cup coconut milk
1 tsp turmeric
1 tsp chili powder
½ bell pepper
salt

Cook the lentils for half the recommended time.

Heat the oil in a saucepan. Chop the onion, carrot, potatoes, and zucchini. Fry the vegetables for a few minutes; do not let them gain color. Add the coconut milk and spices. Chop the bell pepper. Add the chopped bell pepper and lentils to the saucepan; cook the mixture until the lentils are soft.

Serve with wheat berries or rice. Voilà!

BEAN AND LENTIL BURGERS

Oh jeez, these are good! I can eat them anytime, in summer with a light salad and roasted or grilled root vegetables, or in autumn or winter with tasty mashed potatoes or roots vegetables, with lots of butter or oil, and salt.

APPROX. 12 BIG BURGERS

1 ¾ cup cooked black beans
¾ cup cooked green lentils
¾ cup cooked red lentils
1 egg
3 tbsp cornmeal
½-1 fine chopped onion
salt and pepper
olive oil for frying

Mix everything in a blender. Form the batter into burgers; fry in olive oil.

I added some turmeric in the burgers pictured, hence the color.

ZUCCHINI LASAGNA

Zucchini is an easily-cultivated vegetable, but towards autumn they can be very big and not too exciting. That makes them perfect for making lasagna. Instead of regular lasagna noodles, use thin slices of zucchini.

AN 8X8 PAN (4 SERVINGS)

1-2 zucchinis
¾ cup cooked red lentils
olive oil
¾ cup crushed tomatoes
1 clove of garlic
chili powder
1 onion
1 handful of chard (approx. 15 leaves);
 the stalk is also edible
4 cups of grated cheese, preferably a
 bit mature

Chop the onion and garlic; sauté half of it in olive oil. Add the crushed tomatoes, and let simmer for 10 minutes. Add the lentils to the sauce. If you'd like, add chili powder to taste.

Cut the chard into pieces; sauté in olive oil along with the remaining onion and garlic.

Add a layer of zucchini slices in the bottom of the pan. Pour the tomato sauce over the zucchini, and then add another layer of zucchini. Next, add the fried chard, and then one last layer of zucchini. Top with a layer of grated cheese.

Bake in the oven at 400°F for 20-30 minutes. *Yummy!*

RED CABBAGE SALAD

I am a vegetable and salad lover like no other, but during autumn and winter, my body craves cabbage in place of fresh lettuce. Red cabbage can stay fresh until spring when stored in a good cellar, so this salad is a regular on our menu.

½ small red cabbage
½ apple
1 cup cheese
1 avocado
olive oil
salt and pepper
1 handful of walnuts

Shred the cabbage with a cheese slicer if you have one, or cut it into thin shreds. Cut the apple, cheese and avocado into smaller pieces. Mix everything and add some olive oil. Salt and pepper. Spread some walnuts on top, and it's ready to serve.

LENTIL SOUP

½ cup pumpkin seeds
½ onion
2 cloves of garlic
4 potatoes
2 carrots
1-2 tbsp olive oil
½ tsp turmeric
1-2 tsp chili powder (depending on how hot your chili is)
2 ½ cups water
2 tbsp vegetable stock powder
¾ cup red lentils
1 cup coconut milk

Chop the onions and garlic. Peel the potatoes and carrots; dice into small pieces. Sauté the vegetables and spices together in olive oil.

Add water and stock powder, and boil for 20 minutes. Add the lentils, and allow the mixture to boil for another 10 minutes. Add coconut milk, and bring to a boil again. Mix the soup in a blender to your preferred texture.

Sprinkle the soup with roasted pumpkin seeds before serving.

TRUFFLES

The best alternative to the classic chocolate ball! If I want the confection to be richer, I add ½ cup of oats and some more coffee or water.

16 SMALL PIECES

18 dates
4 tbsp cocoa
2 tbsp coconut oil or butter
½ cup chopped almonds
¼ cup almond flour
¼ cup coffee (optional)

Soak the dates in water for a couple of hours, then strain. Mix all the ingredients in a blender, but reserve some of the cocoa. Roll into balls and powder with cocoa. Put the truffles in the freezer for the best texture.

Tip! Use the soaking water for your bread dough. It stays fresh for a couple of days in the fridge.

ICE CREAM

The simplest dessert! Whenever I have bananas at home that are turning overripe, I cut them in slices and put them in the freezer. Then I can make my favorite summer dessert any time.

frozen banana slices
milk (I usually use oat milk)
flavoring, such as cocoa, berries, jam or vanilla powder

Mix a handful of frozen banana slices in a blender with some milk and the flavor you like. My favorite is strawberries with some strawberry jam, or just cocoa.

BANANA CAKE

2-3 overripe bananas
¼ cup coconut oil or melted butter
2 eggs
¼ cup milk
¾ cup teff, rice, wheat or dinkel flour
2 tsp baking powder
2 tbsp ground cardamom
2 tsp cinnamon
½ cup walnuts

Mix all the ingredients in a blender (add baking powder towards the end) and pour the batter into a pan greased with butter and sprinkle with crumbs. Bake at 375°F for approx. 25 minutes.

KILIAN'S FAVORITE BISCUITS

12-16 BISCUITS

10 tbsp butter
¾ cup wheat flour
¾ cup oats
½ cup chopped hazel nuts
2/3 cup chopped dark chocolate
¼ cup coconut flakes

Mix all the ingredients. Roll into balls and flatten each one with your hand to approx. ½ inch thick. Bake the biscuits at 375°F for 10-15 minutes.

CINNAMON BUNS,
OR APPLE AND ALMOND BUNS

APPROX. 24 BUNS

2 cups milk
1 package yeast for sweet doughs
½ cup soft butter
3 tsp ground cardamom
½ tsp salt
¾ cup sugar
6 cups wheat flour

FILLING, CINNAMON BUNS
½ cup soft butter
½ cup sugar
2 tbsp cinnamon

FILLING, APPLE AND ALMOND BUNS
½ cup soft butter
½ cup sugar
1 grated apple
½ cup chopped almonds
¼ almond flour
Icing
1 egg
chopped almonds

Place the dough on a floured surface, and roll until approx. ½ inch thick. Spread the butter and the rest of your chosen filling; roll it up and cut into pieces. Place the pieces into a baking dish.

Allow the buns to rise for 30 minutes. Brush with whipped egg and spread with chopped almonds. Bake at 425˚F for 6-8 minutes.

SOURDOUGH

I love sourdough! Ever since I took my first bread baking course, I've always kept sourdough at home. It's not difficult at all! If you put some time into it and dare to experiment, you will soon get the hang of it. You just have to remember to feed your sourdough. The texture can be everything from pancake batter thick to more like bread dough. I usually use wheat and rye flour for my sourdough.

DAY 1

Mix ½ cup water and ½ cup wheat flour in a big glass jar. Keep it at room temperature.

DAY 2

Now it might start to bubble a little. Add ½ cup water and ½ cup wheat flour again, and stir.

DAY 3

Hopefully it is bubbling more now. Feed it again with ½ cup water and ½ cup wheat flour, and stir.

DAY 4

Now you have sourdough! Put the jar in the fridge. Feed the sourdough now and then, depending on how often you bake with it. If you bake several times a week, you should feed it every time you use it. Otherwise, once a week is enough.

If you plan to bake with sourdough, it's best to bring it to room temperature and feed it the evening before you bake.

BREAD WITH APPLE, WALNUT AND SOURDOUGH

4 cups wheat flour
1 ½ cup water
½ cup sourdough (see previous page)
1 cup rye flour
½ cup steel cut oats
1 cup whole grain barley
½ cup sesame seeds
1 ¼ cup apple sauce (without sugar)
1 cup walnuts
3 tsp salt

DAY 1:

Mix 2 ½ cups wheat flour with ½ cup water and the sourdough.

DAY 2 OR 3 (DEPENDING ON THE AMOUNT OF BUBBLING AND YOUR TIME FRAME)

Add the rest of the ingredients and knead thoroughly. Leave for several hours, or overnight.

Form the dough into a big loaf. (You might need some additonal wheat flour.)

I always put the oven at maximum temperature when I put the bread in, and after 10 minutes, I lower the heat to 400°F.

The bread is done when it has an internal temperature of 200°F. Check the temperature with a thermometer; usual bake time is approx. 45 minutes.

OAT BUNS WITH SOURDOUGH

DAY 1
2 ½ cups water
3 cups wheat flour
2-3 tbsp sourdough

DAY 2
½ cup rye flour
2 tsp salt
½ cup sunflower seeds
1 ½ cup oats

DAY 1

Mix the wheat, water, and sourdough, stir and leave for 24-48 hours.

DAY 2

Add wheat, salt, sunflower seeds, and oats. Leave for 24 hours.

DAY 3

Roll the dough into buns, and place on parchment paper on a baking sheet. Bake at 400°F for approx. 20 minutes. Sprinkle some sunflower seeds on top, if you want, before the buns are put in the oven.

CRISP BREAD

So easy to make and so tasty!

¾ cup oats
¾ cup rye flour (works with any flour - maize, teff, rice, chickpea or wheat!)
2 ½ cups chopped nuts and seeds (¾ cup sunflower seeds, ½ cup pumpkin seeds, ¾ cup hazelnuts, ½ cup sesame seeds)
3 ¼ cups water
salt
dried berries or dried, chopped fruit for more luxurious bread (optional)

Mix all of the ingredients, then spread in a thin layer on parchment paper on a baking sheet. Bake at 350°F for approx. 20 minutes. Remove the bread from oven, and cut into pieces. Put the pieces on the baking sheet again, and bake until crisp (approx. 50 minutes longer).

GLUTEN-FREE BREAD
WITH CHICKPEA FLOUR

It's fun to experiment with different types of flour and grain, especially when I bake gluten-free bread. This is a basic recipe I use, but every so often I replace the type of flour.

¾ cup oats
1 cup liquids, such as milk or coconut
 milk
1 cup teff flour
1 cup flax seeds
½ cup chopped almonds
½ cup walnuts
½ cup chickpea flour
¼ cup psyllium husk powder
2 tbsp chia seeds
1 tsp salt
3 tbsp dark syrup or 1 banana

Mix all ingredients. For approx. 10 small buns. Bake at 350°F for approx. 20 minutes. Super easy!

WE HAVE BEEN RUNNING SINCE ANCIENT TIMES; MAYBE THAT IS ONE OF THE ABILITIES THAT HAS TAKEN US TO WHERE WE ARE TODAY?

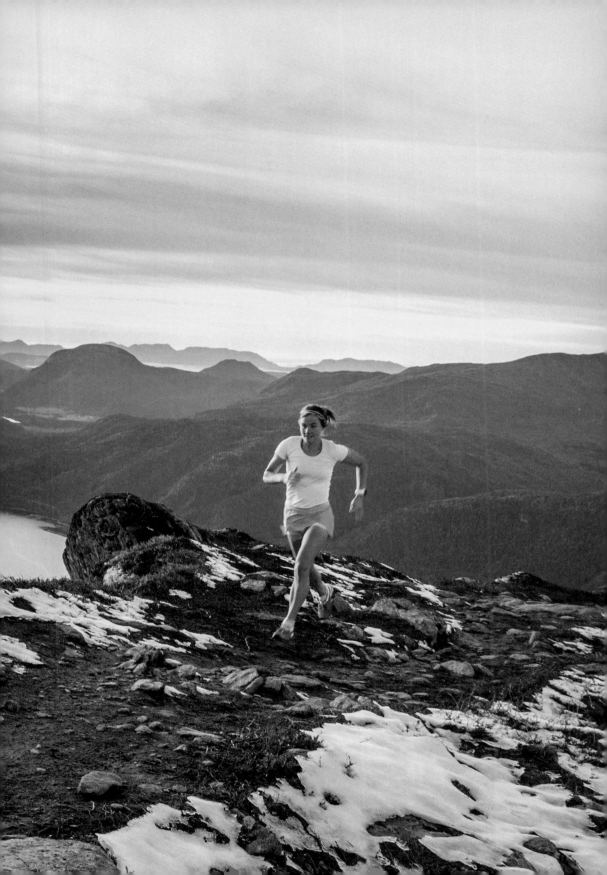

[BREATHING]

Inner and outer journeys. About yoga
and what it means to my running. And some
yoga exercises, of course.

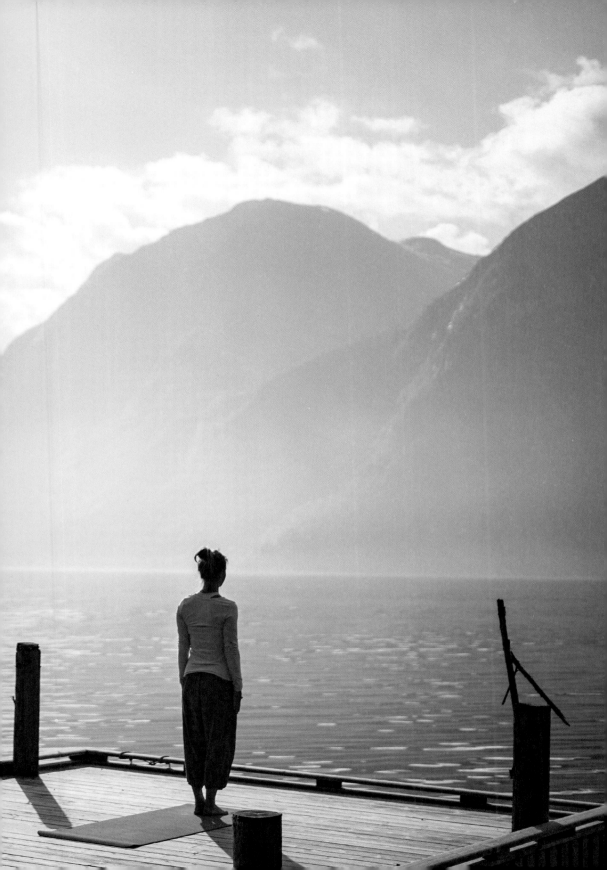

[BREATHING]

— RISHIKESH, INDIA, 2016 —

The alarm goes off. It's 4 a.m. In one hour, Pranayama starts, a breathing exercise and our first lesson of the day. Despite the fact that I have a long day ahead of me, I put on my running clothes, tie my shoes, and head off. It's pitch black outside. I start to run through the lantern-lit village, out toward the jungle, and along the Ganges, the holy river. The wild dogs follow me, as usual. It's nice to have some company. No one else is awake. Where the village ends and the lights run out, I patter cautiously along the narrow road. It's hot, stuffy, a bit eerie, and soon I turn around, filled with energy for the day.

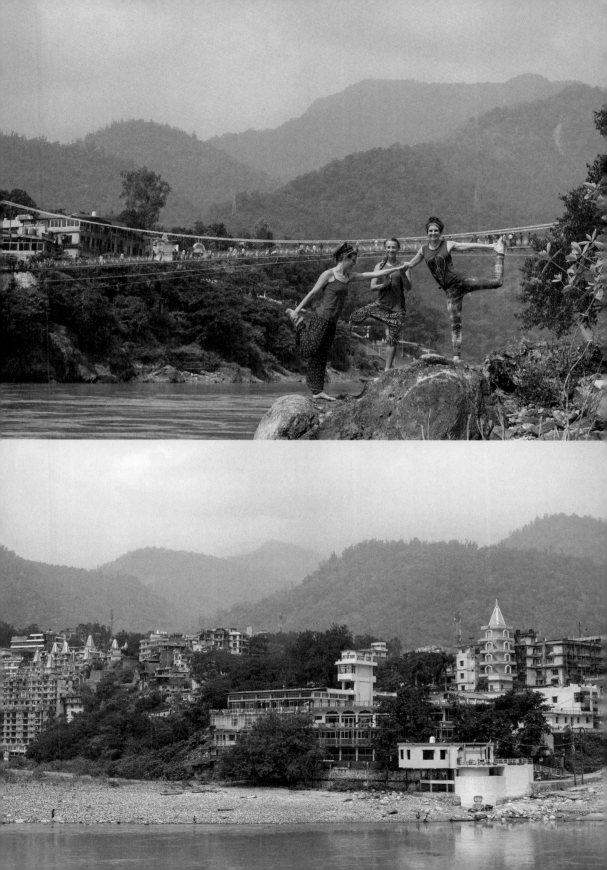

The connection—what running and yoga have in common. Both have a simple core. Both connect body and mind, and when that happens the feeling is immense!

RIGHT FOCUS

I had promised myself to focus only on the course during my month of yoga teacher training. The schedule was packed from half past five in the morning to eight o' clock in the evening, with only a three hour break in the middle of the day. I have to admit that even on the first day, I had already started to think about how to get an hour of running into my day, and where it was possible to run. It was ideal to focus one hundred percent on yoga, and to maintain running at the same time. This was easier said than done. In the middle of the day it was nearly 104°F in the shade, and the treadmill at the gym felt dangerous. The first time I had tried it, the power cut in the middle of my run. The best alternative was to get up and run before the day's exercises. But after just a few days I realized this was not sustainable; getting up before 4 a.m. to run made me too tired, and too unable to focus on what I was there to do.

I told myself not to stress: this was a month with a focus on yoga. As I managed to let go of the thoughts of running, it was easier to go wholeheartedly for the yoga. And the few days when I did wake up before the alarm, the short morning runs with the dogs were wonderful and energetic. I had found my balance.

LET GO

The yoga training was a big step for me. I had just returned to a relatively normal everyday training schedule after my cruciate ligament surgery, and I had been able to run a few races. But something didn't feel right. I still couldn't give my all when running, and I still needed to do a lot of rehab and to take care of my knee. Maybe that's why I became more convinced that I needed this trip now. When would I otherwise have time to be away from my normal life for an entire month?

I also needed some time for mental training, not only physical. After so many months of having all my energy concentrated on the rehab, of analyzing how my body answered to the physical training and worrying about my shape not coming back, I needed something totally different to help find my balance. It was going to be a challenge to be away an entire month, without even thinking about training and races. And the first two weeks were without Internet as well. No social media, and no emails.

The two first weeks were the best. When I learned to be at ease with not running, and when I got into yoga and my studies, I found it was a very welcome break to learn to do something completely different from what I usually do. It was as if I got some distance from my running, yet I was fully present. I let myself rest. I dared to let go. The running was still there, I just had to do something else to find my way back again. ▲▲

EXPLORE

Yoga has been with me, more or less (mostly less), since I was 16 years old and took my first yoga course back home at the High Coast. After that, I only did classroom yoga sessions. But a few years ago, I started to do yoga more regularly in the morning. I felt like it gave me some distance from the day and a closeness to both body and soul. The yoga became a complement to running, a time to stretch each little muscle and really feel how my body answered to my training. And from there I could work on my stiff muscles. Controlled breathing, or breathing completely free in pranayama, breathing exercises, or just letting the breath come and go, as it pleases.

Yoga is not supposed to be complicated or uncomfortable. In yoga, I am forgiving toward myself, I can challenge my mobility with great tenderness. I try to be fair to myself, to focus on the small details, to see the ultimate pose but work from my own requirements and where I am at that moment. I try to put aside feelings of shortcomings toward my body, for example when I work with my stiff shoulders and back, and feel like a huge, square fridge. I know that it's good for me, although it is incredibly uncomfortable in the moment. Exactly like in running, you need to be forgiving and understanding within yoga, and more importantly, find what makes you want to go back.

I have noticed that I am more understanding in my approach to yoga than to my main sports. Probably because it is something relatively new to me, something I need to learn. I need to convince myself more, as I lack the natural motivation. I have brought this to my running and skiing, too—to be more forgiving and patient. Although I am more comfortable and confident in these sports, I still need to remember to pause. To listen. Ninety-nine times out of a hundred, it's just about moving on with the training session, but if I do not listen inwardly, I might miss something important that hundredth time, like the need to quit in time or to adjust something. Maybe that particular time, that is what's necessary to make the training sustainable.

I do not believe that we, as runners, need to be extremely flexible to be our best running selves. When I was at my most flexible—which was still nothing to brag about—I felt rather that I had less control over joints and muscles. As someone who runs a lot of uphill and downhill, my tight joints might even be an advantage and decrease the compression on the skeletal structure, avoiding strains.

One of the most inspiring teachers I had at the yoga school in India was very individualistic in his exercises. He saw how each and every one of us worked from our own requirements, just like we have to do with everything in life. Such a simple philosophy, so obvious, yet still so easy to forget.

To get to know your body, pause and breathe. These are the important factors for lasting a long time, I believe, both physically and mentally. I think that yoga helps me to see the bigger picture, see beyond the physical performance just there and then. That in turn helps me to focus. It does not necessarily have to be yoga itself, but just that I have learned to shut out the thoughts that prevent me from performing my best, or from feeling my best. It helps me to direct my thoughts inward, to shut out the world around me. That gives me peace in my restlessness and motivates me to do my duties in the best possible way, without thinking of results. ▲▲

BEGIN AT
THE BEGINNING

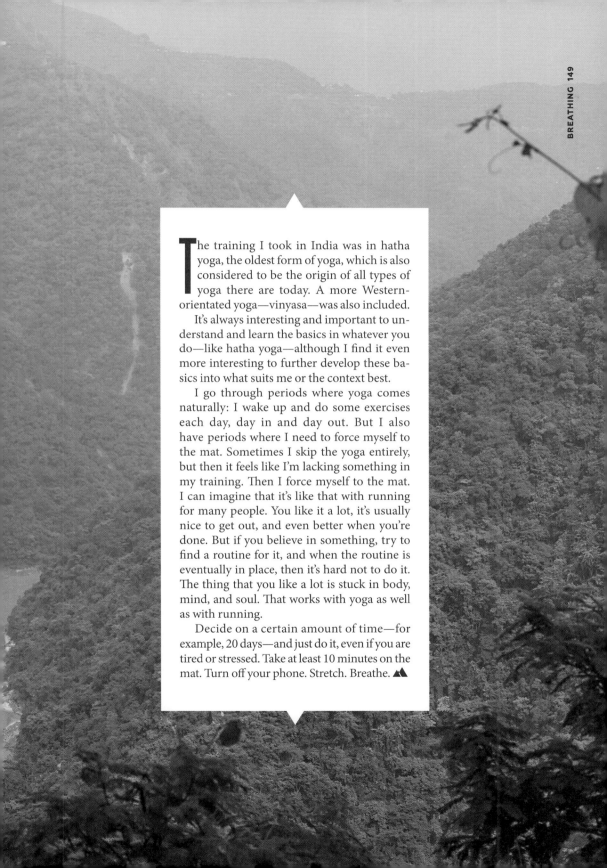

The training I took in India was in hatha yoga, the oldest form of yoga, which is also considered to be the origin of all types of yoga there are today. A more Western-orientated yoga—vinyasa—was also included.

It's always interesting and important to understand and learn the basics in whatever you do—like hatha yoga—although I find it even more interesting to further develop these basics into what suits me or the context best.

I go through periods where yoga comes naturally: I wake up and do some exercises each day, day in and day out. But I also have periods where I need to force myself to the mat. Sometimes I skip the yoga entirely, but then it feels like I'm lacking something in my training. Then I force myself to the mat. I can imagine that it's like that with running for many people. You like it a lot, it's usually nice to get out, and even better when you're done. But if you believe in something, try to find a routine for it, and when the routine is eventually in place, then it's hard not to do it. The thing that you like a lot is stuck in body, mind, and soul. That works with yoga as well as with running.

Decide on a certain amount of time—for example, 20 days—and just do it, even if you are tired or stressed. Take at least 10 minutes on the mat. Turn off your phone. Stretch. Breathe. ▲▲

– EXERCISES –
YOGA – THE BASICS

*Find your natural position and
begin your day by saluting the sun .*

An important insight I gained as I took my yoga teacher training was that the body has a natural position in each yoga pose. It doesn't have to look exactly like it does in the yoga book. It's more important to work from your own abilities and to find your own natural position in each yoga pose. Begin by working through the position of your body and start from the bottom.

FEET POSITION AND GRAVITY
Stand with your feet together, so that they touch each other. Feel all four corners of each foot, and the balance between them. Rock back and forth a little, and feel how the distribution of your weight changes, and then regain your balance. When the foundation is stable, shift focus to your lower legs and thighs. Tighten them a little, imagine the muscles going a bit "inwards".

HIP POSITION
Find the neutral position of your hip. If you are uncertain, arch your lower back and notice how the weight on your feet changes. Find your center of gravity all the way up from your feet.

BACK AND CORE
Continue to your lower back and stomach. Tighten your stomach muscles, and notice how your back straightens a tiny bit. Breathe in this position. Do not tighten too much; just straighten your posture without forcing your breath.

SHOULDERS AND THORACIC SPINE
Roll your shoulders back, so that you feel the gap between your shoulder blades getting smaller. Relax your shoulders and let your arms hang along the sides of your body. Let your neck relax, and lean your head carefully to the right, and then to the left. Once you are back in a neutral position, imagine your head being pulled up, so that your neck straightens.

This is the first position in the sun salutation Tadasana, the mountain pose.

SURYA NAMASKAR – SUN SALUTATION

The sun salutation is probably the sequence of movements that is most often associated with yoga, and there is a good reason for this. Surya Namaskar is a tribute to the sun; without the sun there is no life. A daily sun salutation is a tribute to the sun and to yourself.

The sun salutation is a sequence of simple positions, either practiced in a flow, which means to change position with each breath, or separately while staying in each position for several breaths. I choose my pace and breathing depending on whether I want more energy, or if I want a slower yoga practice.

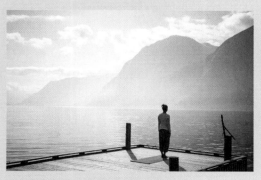

1 TADASANA – MOUNTAIN POSE

Go through your entire body, step-by-step, as described on the previous page. The foundation is built from the bottom up.

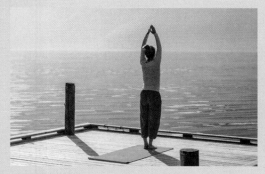

2 URDHVA HASTASANA – UPWARD SALUTE

Inhale and swipe your arms up. Keep your center of gravity down, with straight arms and a straight lower back. If possible, bend your thoracic spine backwards a tiny bit, and look up for a little stretch.

3 UTTANASANA – STANDING FORWARD BEND

Exhale and bend forward at the same time. Squeeze all air out of your lungs. Legs should be straight and strong, neck and back relaxed.

4 ARDHA UTTANASANA – STANDING HALF FORWARD BEND

Inhale. Stretch and extend your back so that it straightens. Look up halfway.

5 CHATURANGA DANDASANA – PLANK POSE.

Exhale and jump or step back to plank pose. Tighten your back and stomach.

6 URDHVA MUKHA SVANASANA – UPWARD-FACING DOG

Pull back your shoulders; open up your chest. Let your legs be active, and the gluteus muscles (the buttocks muscles) relax.

7 ADHO MUKHA SVANASANA – DOWNWARD-FACING DOG

Maybe the world's best yoga pose! Here, you stretch and open up in so many places. Straight arms, straight lower back, and straight legs are what you should aim for.

8 UTTANASANA

Exhale and jump or step forward, bringing one leg at a time between your hands.

9 ARDHA UTTANASANA

Inhale and stretch out your back. Bend at the hip.

10 URDHVA HASTASANA

End the circle with an upward salute.

11 TADASANA

Finish with the mountain pose.

After the sun salutation, I have some exercises to which I always return. These are exercises that suit my runner's body, which is strong, but with stiff back, hips, hamstrings, and thoracic spine. This program takes me about 15 minutes, and if I take that time before breakfast, I know that I have listened to my body and can use it to the best of its ability during the rest of the day. Usually, I do these exercises in the following order:

1 MARJARYASANA – CAT POSE

I almost always start my program with the cat pose, partly to loosen up my lower back, partly to feel the movement of my hips. As you tip your pelvis backwards and round your spine, your back will get a good stretch and the air will be squeezed out of your lungs. Next, inhale and arch your back and look up. Here, you work with the mobility of your whole spine and your hips.

Arch and round your spine; inhale and exhale at your own pace. Feel how your back loosens up.

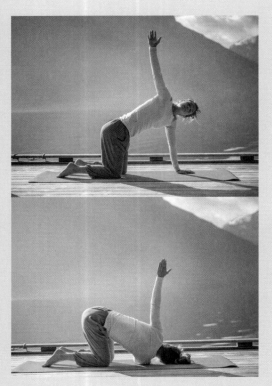

2 MARJARYASANA, VARIATION – CAT POSE WITH TWIST

It is common for runners, skiers, office workers, and many others to have a stiff thoracic spine, so this is a very beneficial exercise. Even though my upper body is very stiff, I still find this pose manageable. The thoracic spine gets a little stretch, as do the triceps and biceps.

Begin the cat pose. Inhale, and bring your right arm up. Then, bring it under your body. Fold your upper body forward in this twist, and breathe. Notice how your thoracic spine loosens.

Stay in the pose for a couple of breaths, and then do the same with your left arm.

3 AFTER MARJARYASANA I SIT ON THE MAT AND STRETCH THE SIDES.

In a seated position, feel your weight distributed evenly on both buttocks. Cross your legs, straighten your back, and keep your lower back and belly strong, and your neck proud. Lean toward one side; bring one arm up and let the other rest on the floor. Feel the stretch on your side. Inhale, and bring your body back to a straight position. Exhale, and lean to the opposite side. Focus on your breathing again. How does it feel? Are your inhalations and exhalations equally long?

4 VIRABHADRASANA 1 – WARRIOR POSE 1

This pose is good for stretching the hip flexors and working with strength in both legs.

Begin in Tadasana, mountain pose. Take a big step backward. Turn your rear foot toward the corner of your mat. Bend your front leg 90 degrees, or as much as you can comfortably manage. Feel the stretch in the hip flexors and straighten your rear leg. Feel how your weight is distributed between the corners of your feet.

Before you stretch your hands in the air, place them on your hips to check the position of your hips. Are they stable and pointing forward? In yoga, there are either hip-opening poses, or poses where the hips point straight forward. In this pose, your hips should be parallel and pointing forward. Lengthen the lower part of your back by tightening your stomach muscles.

When the lower part of your body is in balance, you can raise your arms.

5 VIRABHADRASANA 2 – WARRIOR POSE 2

From warrior 1, I go directly into warrior 2, a hip-opening pose.

Turn your rear foot about 90 degrees. This movement opens the hips. Feel that both legs are working; do not lean on the front one. Make sure that your upper body is not leaning in any direction. It should be aligned over your hips. Raise your arms parallel to the floor.

6 VIRABHADRASANA 3 – WARRIOR POSE 3

This is a fantasic pose for strengthening your legs and the back of your thighs, and for improving your balance. One of my favorites, this pose can require some time and practice.

Start from Tadasana, the mountain pose. Lift one leg backwards, and lean your upper body forward. When you bend forward, your rear leg should naturally lift. Work from your hips, keep them parallel to the ground and do not let them tilt forward. Imagine that you are able to put a tray on your lower back/buttocks.

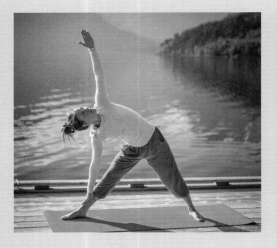

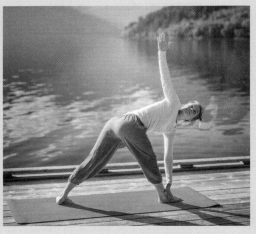

7 TRIKONASANA – TRIANGLE POSE

Take a step back (a bit shorter than for the warrior pose). Both legs should be straight, and your rear foot should point toward the corner of your mat. Raise your arms straight out from your body and extend your upper body before you bend to the side. One hand will extend toward the lower leg/mat, and the other will extend straight up,

8 PARIVRITTA TRIKONASANA – REVOLVED TRIANGLE POSE

This is another great pose for balance, upper body twist, and leg strength.

Come back up from the triangle, but keep your feet in the same position. Bring the opposite arm toward the mat. If you do not reach the mat, place your hand on your lower leg. Feel the twist in your upper body, but the foundation should still be in your feet, legs, and hips.

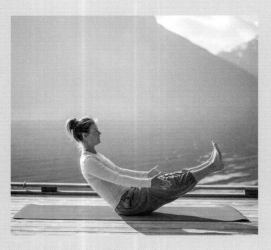

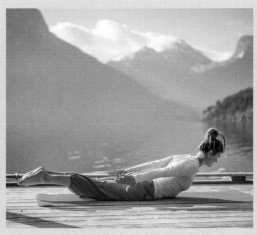

9 NAUKASAN – BOAT POSE

This pose activates the abdominal muscles, which are so important for a good running posture! Sit on the mat with your legs forward. Begin by bending your legs to a 90-degree angle. Lift your legs and lean backwards. Then, try to straighten your legs. Work with a straight back.

10 VIPREET NAUKASAN – REVERSE BOAT POSE

Pose and counterpose; to do a counterpose is good for the balance of the body. So, if you do a forward bend, it is good to do a backward bend directly after.

Lie on your belly on the mat. Put your arms along your body, and lift both arms and legs.

11 TADASANA A – MOUNTAIN POSE
Press down the four corners of your feet and feel the balance. A straight back, even hip position, and shoulders pushed backward make the foundation stable. Place your arms by your sides.

12 TADASANA B
Stand with your feet shoulder-width apart. Raise your arms up, also shoulder-width apart. As you raise your arms, stretch up on your toes. Bend your knees to a 120 degree angle. Hold this pose; take a couple of breaths. Your whole body, including your abs and back, should be active.

13 VRIKSHASANA – TREE POSE
This is one of my favorite poses. It does so much good for runners: you train your balance, the small muscles in the feet and ankles, and open up your hips. Stand on one leg, and bring the other foot to your groin or calf. When you have found balance, you can raise your arms up high, shoulders relaxed. Breathe.

14 VAKRASANA – HALF SPINAL TWIST
Finish by sitting on the mat with one leg straight and the other leg bent. Put the opposite hand on the bent leg, twist your upper body, and look over your shoulder.

For additional strength: hold the standing poses longer. Work with the sun salutation; aim for one breath per pose.

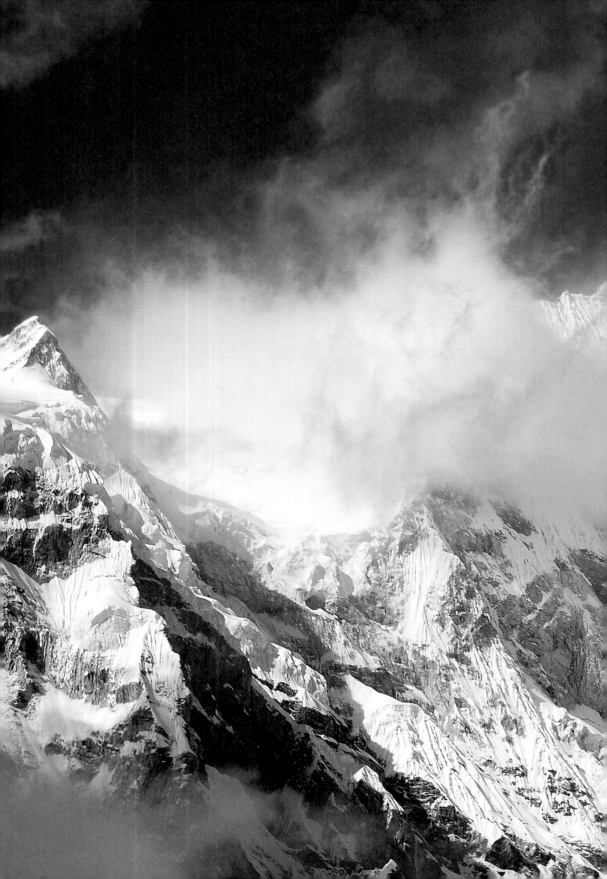

CHAPTER 8
[ETERNITY]

And all its possibilities.
About testing your limits and daring
to make the right decision.

[ETERNITY]

— CHO OYU, TIBET, 2017 —

Cho Oyu at sunrise. The sun starts to warm up the tent and the sleeping bag. Soon it's time to get up and hang out the moist sleeping bag to dry. I open the tent, but I stay in my warm bag. What a view! The more the sun heats up, the easier it is to leave my sleeping bag. A lot of hours are spent in the tent and the sleeping bag when you're on an expedition—from sunset to just after sunrise. Pure holiday.

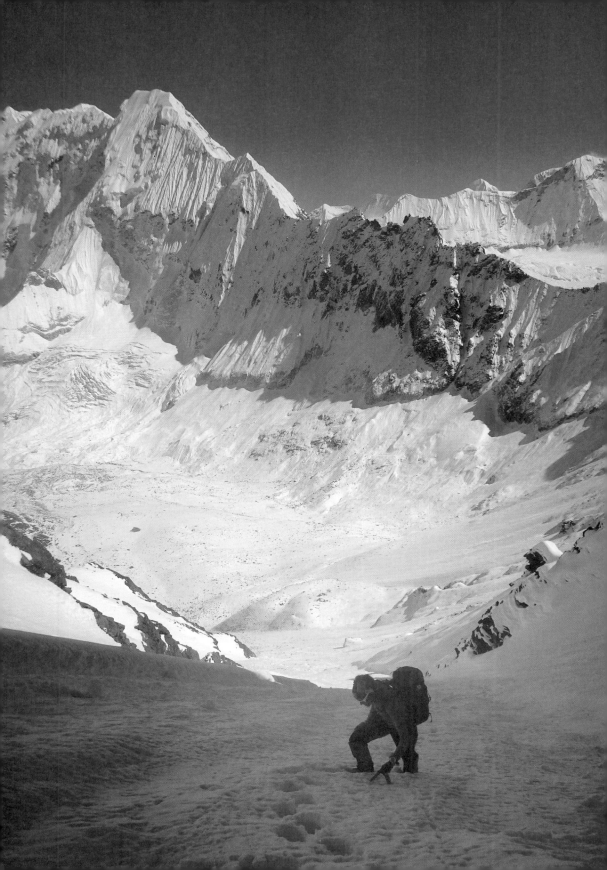

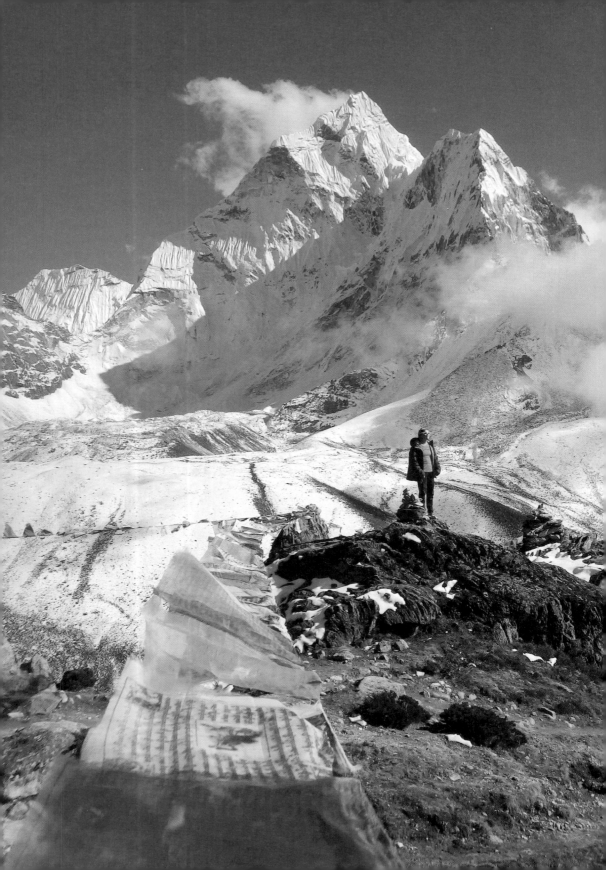

ALTITUDE TRAINING

Before I crawl out of my sleeping bag, I think back on the weeks before the expedition started: the mornings when I was awakened by condensation dripping on my nose, and I had to coax my arm into the small upper body tent to wipe it away. After I'd managed to get the arm out again, I'd look at my watch. I usually woke up around quarter to six; one hour before my ten hours in the artificially-thin atmosphere were completed. As it was barely even possible to turn around, I'd stay on my back, waiting for the time to pass. This was mine and Kilian's acclimatization for Cho Oyu, one of the world's fourteen summits over 26,247 feet.

Before we started our hike towards Advanced Base Camp (ABC) at 18,700 feet above sea level, I'd amassed 340 hours in a high-altitude machine, a machine that decreases the amount of oxygen in the air, thereby simulating the altitude you wish. For four weeks, we had been sleeping in that small tent. Additionally, we had trained one hour each day with a mask connected to the machine, on a treadmill or exercise bike. It sounds horrible, and sometimes it was. I was tired from sleeping at high altitude, I couldn't train as hard as I wanted, and who wants to run indoors when the sun is shining outside the window?

THE PLAN

It was on a longer run last autumn that Kilian and I started to talk about fast ascents to the highest summits in the world. We had just heard about a couple that summited Cho Oyu in two weeks from home to home. Now this interested me! High altitude alpinism was definitely fascinating, but the idea of base camp for almost two months had always discouraged me. It never appealed to me.

The feeling that something this huge and eternal even exists makes life seem simple, strangely enough. Maybe everything doesn't matter that much after all?

While running our regular long run over Skarven back home in Romsdalen, we started to play with the idea of doing a faster trip to Cho Oyu, planning how we would set it up, with or without base camp facilities.

Was it a shortcut we took by trying to acclimatize at home instead of spending six weeks at base camp? It was clearly something new, and we didn't talk to others about it. If we succeeded, so be it. Maybe this could be a way to get up to high altitude and at the same time be at home and live our regular everyday lives with work and family. I like the actual idea of focusing on one thing for several weeks, like you do on a normal expedition. This was just a new way to focus.

The weeks passed by, and the sleep got better and better at the simulated altitude. The date was getting closer. I did longer and longer training days; up to 12 hours to prepare my body for the summit attempt. I trained to become confident in more technical terrain, like ice and rock, and I skipped the faster, shorter, and harder sessions because I simply didn't recover from them. Sleeping at high altitude eats away your power.

BASE CAMP

The skiing season ended and it was time to leave. In only a couple of days we were there. It was unbelievable: prize ceremonies and celebrations after the last ski race for the season in Italy the one day, and shortly after, small and insignificant with the world's most powerful mountain chain ahead of us.

We were dropped off at the end of the road on the Tibetan high plateau and started our hike towards Advanced Base Camp. According to our research and our map, it was about 5 miles along a glacier. In the distance, we saw nameless mountains on the border of Nepal. We hiked quietly and I thought of what the altitude felt like. Nearly 16,400 feet. How was this going to be? Is it possible to acclimatize in a high-altitude machine, really? The oxygen level could be simulated, yes, but what about how the air pressure would affect the body? Was it stupid to even try this method? From what we knew, no one had tried this before. The others that had acclimatized in a high-altitude machine at home had started to use oxygen already at Base Camp, which means four liters of additional oxygen per minute.

My thoughts abounded and my eyes were drawn yet again to the big, beautiful, true calm around me.

There and then, as our expedition started, everything felt so possible, yet at the same time so far away. Without computer, telephone, or Internet this was so fresh and new, like a new notebook just waiting to be filled with bubbling, sparkling thoughts. No distractions, like waking up with a cup of coffee and a new day ahead.

After two hours of hiking, we can see our goal. Cho Oyu. 26,906 majestic feet above sea level she reaches, up towards the sky. The summit makes me feel tiny. The feeling that something this huge and eternal even exists makes life seem simple, strangely enough. Maybe everything doesn't matter that much after all? Not in the sense of being meaningless, just that even if my choices are important, they are

important with a distance.

Now we can make out the tents at base camp, 14 of them. Soon we are greeted by happy faces: seven guests, their sherpas and guide, and our chef for the next ten days. It's sunny and warm in the air, and Cho Oyu is looming in the far distance.

A NEW DAY

I love the feeling of waking up early to a new day, of not knowing what the day is going to look like. My curiosity is so great that I can barely wait to get up in the morning. Our first day in the tent is like that. I look at my watch. When will the sun reach our tent? At what time does it reach camp 1, camp 2, and camp 3?

I step out of the tent with my big down jacket wrapped around me. The sun is up, but isn't touching our camp yet. It is quarter to seven. I walk to the food tent and take a cup of green tea. Shivering slightly, I sit down to wait for the sun to rise behind Cho Oyu, and only a few minutes later the first sun rays are warming my cold cheeks. It's so beautiful that it hurts. I feel so lucky to be here right now.

The second day of our expedition, we walk up to camp 1 at 21,000 feet, with tent, sleeping mat, stove, and food for later. We meet the sherpas who have carried tents, ropes, and food up for their first expedition. They are strong. We greet them happily, and start to talk about the way up. It's a bit different this year; only two small expeditions are at the mountain, which means more work for the sherpas, as they still need to put up fixed ropes all the way to the summit, even though there are only six sherpas.

We walk down again the same day, as we were only bringing the equipment up. In two

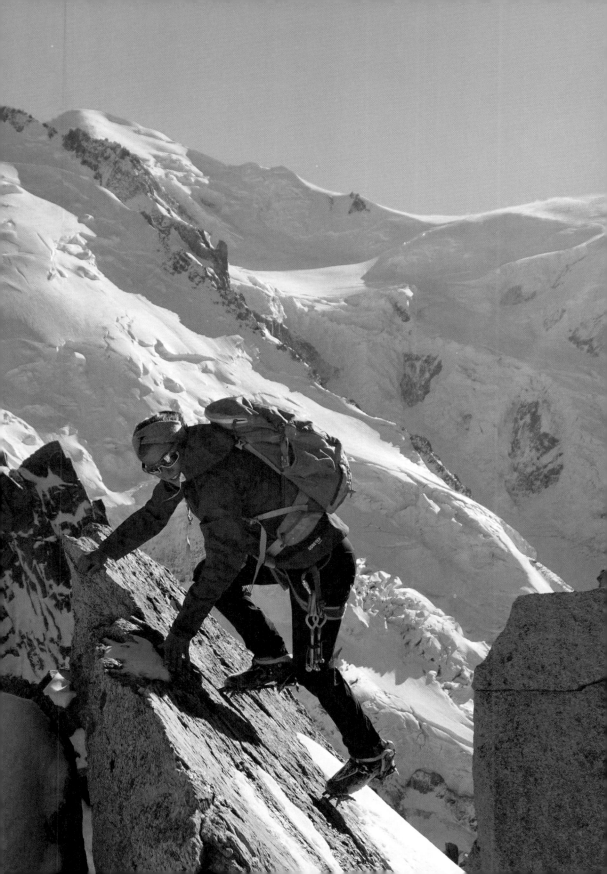

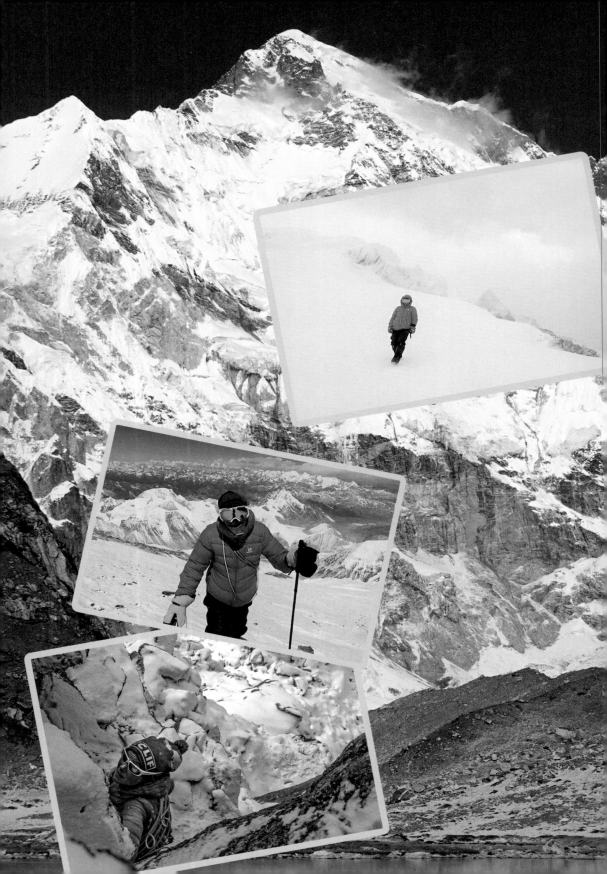

Just up, up, up through the viscous atmosphere.
Straight up toward the sky.

days we'll be sleeping up there. So far, our acclimatization plan works. We're doing great, without any signs of altitude sickness.

In the afternoon on the third day, we walk up to camp 1 to sleep there. We're all alone. A small orange tent on a plateau, just ahead of the first big icefall we're going to climb. In the evening, we melt snow and cook dinner inside our tent, because when the sun goes down, the temperature goes down drastically, too. We hope that the latest weather forecast is right, that the next day will be sunny without wind, because we want to try to walk up to 24,278 feet.

UPWARDS

Day six: We start with the sun and make our way through the glacier. We have two large ice walls to climb, which are more difficult than we expect, as Cho Oyu is supposed to be one of the easier summits at 26,246 feet. But after some small detours, we're soon up on the plateau between camp 2 and camp 3. It's completely empty. No people, no ropes, no tents. We're all alone. Yet I get a feeling of adequacy, and confidence in Kilian and in myself. I need to be the decision maker, to take responsibility, climb on my own, I cannot rely on anyone else to help me up and down. Now it's time to be honest. A lot is at stake, exactly how it's supposed to be in the mountains. I am ready, I know this—both to continue, and to turn around.

We continue up to camp 3. For an expedition with oxygen and sherpas, this is as far as

they go on the third day of their summit attempt. For the entire summit attempt they take six days up and down. That's many days in the mountains, and I cannot imagine what it's like to breathe oxygen all that time, to be at 26,246 feet, but at the same time feel like you are 6,500 feet lower. And that somebody else is carrying your back pack and clipping you in on the rope, on which you pull yourself up.

At 24,278 feet, I decide it's time to turn around. This was approximately the altitude we had planned to reach before the real summit attempt. Kilian continues up, just a bit farther, and I start to walk down.

It is an easy slope with hard-packed snow, and it feels safe. But then I slip on the snow, a small snow slab pulling me down and I start to tumble. I have no time to think, and I automatically try to stop my sliding by using the ice axes that I'm carrying, one in each hand. Nothing happens. I only gain speed. One of the axes is pulled from my hand. I put all my weight on the axe that I have left and with a hacking motion, the speed decreases. My heart is pounding. I get up on shaky legs and continue down the mountain.

Imagine what a small snow slab can cause, even on a small slope that felt so safe. I don't want to think about the different scenarios that could have become reality if I had not been able to stop. 1,000 altitude feet at high speed can end badly. Considerably more alert, I continue downward to wait for Kilian.

The spring in the Himalayas usually has stable weather, but we know that it's a gamble

to plan an expedition of only ten days. Now we just need to wait for a good weather window. We have just five days, and we hope for better weather.

We are enjoying life at the camp. We eat well in the food tent that we share with seven people from other expeditions, and we can really stretch out in the tent. The rest days offer nice small talk and we share our experiences. And we all share the same dream: to get to the summit.

TOWARDS THE ETERNAL

On day seven we get three different weather forecasts. They all look different. That probably means unstable weather.

On day eight we wake up to sunshine, but it shifts to snow storms after a while. Then we get reports of a good weather window in two days. We decide to give it a go; we have no other choice! On day nine we walk, excited and a bit nervous, both caught up in our own thoughts, up to camp 1 to start the summit attempt at midnight.

At around 4 p.m, after we've eaten our freeze-dried food and melted snow for the day ahead, the wind starts to pick up. It's a storm. We try not to think the worst thoughts, we just lie in our sleeping bags and try to rest. It works better than expected. I eventually fall sound asleep until the alarm goes off.

When the alarm goes off at 11.30 p.m. the storm is still roaring. We can barely hear each other. We set the alarm for one hour later and hope that the wind will calm down a bit.

But it doesn't. We discuss back and forth. It will be cold and we'll need to keep moving to stay warm. But we agree. Both of us are determined to make a try. Because tomorrow we are going home.

Once we're out and on our way, it doesn't feel that bad. We left everything at camp; we only brought water and gels as energy in our pockets. No backpacks, and only one ice axe

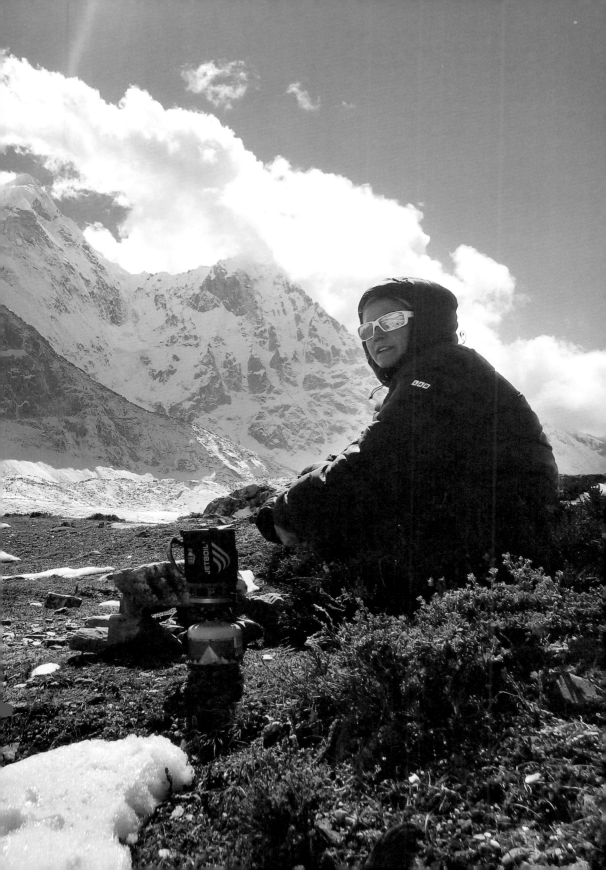

each. We walk and climb in silence. The wind is whipping and whistling. My feet and hands are cold; I can barely feel that I'm holding the axe, but my body is still warm. In the light of the head torch we climb the second ice fall and then I relax. The climb has gone well, but it is still strenuous.

We are now at 22,637 feet. The wind has tortured us the entire way. Neither of us has managed to eat anything; we don't want to stop for a single second because of the wind and cold. It's a bit scary to think that I have to keep moving to not freeze, but I feel confident anyway. I know I can always turn around. I can still move my body; my muscles work because I am strong. I have trained. I know this. Moving.

After about six hours of climbing, we find our way into a glacier crevasse and get some

shelter for the first time since we left camp. We eat a gel but when we try to drink we discover that the water is frozen. It has frozen even though we kept it in thermoses close to our bodies inside our thick down jackets.

It is close to nine and we have experienced a sun rise like no other. My highest ever. We are still in the shade and the wind is still howling. However, in a couple of minutes we will reach the sun and we hope that the wind will calm down. It does, and it's such a relief. We eat and drink the now-slushy water.

We have reached 22,955 feet, about 2,000 altitude feet from our last camp. It has taken us longer than the last time we climbed up, even though the last time we had to pause to find the best route. I push away the thoughts about time, despite its importance. Two o' clock is my deadline and then I need to turn around.

While we rest in the sun, we talk about what a tough night it was. We didn't exchange many words during the dark, cold, and windy hours, so they come now. Both of us are amazed and positively surprised that the altitude is not causing us any issues. It's the tenth day of our expedition and we were able to climb up towards a little over 22,900 feet without any problems.

We continue, but now it's getting harder and harder every foot. 25,252 feet. This is how it's supposed to feel. Each step is a battle. Wow! To be so tired, but still able to continue. The oxygen sets the limit despite your heart beating so slowly. It's like mountain running, but yet something completely different. The freedom, despite our heavy steps, the strong willpower that makes me continue, and the knowledge that it's my own power that makes it possible. Not somebody else's, no shortcut. Just up, up, up through the viscous atmosphere. Straight up toward the sky.

THE HARDEST DECISION

25,590 feet. I look at the watch and we take a break. The clouds start to clog behind the summits; in three hours I must turn around. Can I manage 1,316 feet uphill in 3 hours? It is an absurd question, as normally I can run 3,280 altitude feet in 40 minutes! How can I not make 439 feet per hour? I know it is not comparable, but it's a funny thought.

It is about 328 altitude feet of technical climbing left, and then a long plateau to the summit. One part of me wants to continue without thinking of the consequences, the consequences of not being able to climb down, without thinking of the snow storm that seems to be on its way in, without thinking of the long way back. The part of me that wants to reach the summit. To Cho Oyu. Where I was supposed to go. That's my finish line.

But I shouldn't focus on the time. It's here and now, up or down, step by step. The cold still bites my body, but the warmth is getting closer.

We continue, and at the famous yellow band, a yellow-brown band of marble and other light rocks that was actually below sea level 300 million years ago (!) and is a trademark of the world's highest mountains, we stop again. Here it starts to get difficult. It's a hefty wall, a completely vertical cliff. We had heard it was supposed to be very easy, but it is actually quite advanced climbing. But I guess it can be perceived differently, as there are several ways to climb mountains. First of all, it depends on whether or not you use oxygen. Then, it depends on whether you climb yourself, or pull yourself up using a tool on a rope that has been put up by the sherpas. The latter might not be very hard, so in one way, I guess they're right.

Success and failure are worth thinking about again and again. To learn something, to move on.

The other part of me says turn around. That it's impossible to climb so fast to the summit. That I don't have enough energy after this windy night. I also think about the way down. What if I use all my power to get up? It's a long, technical way back down too. I need to know that I can climb down without assistance. There is no mountain rescue here, no one can help me except for myself. Even though Kilian is with me, we are still up here alone. You must be able to trust yourself.

After a lot of arguing with myself and with a heavy heart, I decide to turn around. I do not trust that I will have enough power and energy to be alert after a summit attempt if there is snow and fog. If the hard weather was not coming in, I might have tried. But I am too cold to dare. If there is another cold spell, it feels like my power could run out.

We talk about my decision. Not many words are needed. You don't stand at this altitude hesitating when the wind is chilling and roaring.

Kilian continues. I know that he can take care of himself and that I can get down on my own, but it's still a more exposed position, of course. To be all alone at 26,906 feet with glaciers and ice falls. It's beautiful and frightening to leave each other. This is what we want. We know this. We make our own decisions. We are independent.

Slowly but surely, I get down to camp 1, pack down our camp and continue down towards the first base camp. The darkness surrounds me and the rising full moon lights up my way back. My thoughts wander with my steps while I follow the edge of the glacier. It feels empty not to have reached the summit. All these preparations, both mentally and physically. So many hours, and still I haven't succeeded. It's hard to handle, and I am happy for the miles I have left in the moonlight. There is nothing else to think about besides going through it in my head, over and over again. It occupies my mind and it's sad, but strangely enough it's also beautiful to feel like this. The disappointment agrees with the happiness of having tried. I collect what I have learned and just let it be. The mountain is still there. I move on, and the lessons are there for another time. I know I did all I could to be as prepared as possible. Sometimes things just don't go as planned, even though you have all the odds on your side. Right now I cannot do more than think about what I have learned and take care of that until the next time. Now it's time to focus on other things.

For me this expedition was something big, something eternal, and to work toward this goal has been rewarding, regardless of whether I reached the summit or not.

Success and failure are worth thinking about again and again. To learn something, to move on. To set new goals, goals that take us further.

The next day we pack our camp, and with the world's highest mountains behind us, run down to the road to take us onward. ▲▲

EMELIE FORSBERG
TRACK RECORD

COMPETITIONS
Skyrunning World Champion 2014
Skyrunning World Cup Winner 2015
KIA fjallmarathon 27 km, 1st position 2017

RECORDS
Mount Marathon Alaska USA 5 km
Ultra Pirineu 110 km
Glen Coe Sky 55 km race record 2017

SKIMOUNTAINEERING
Pierra Menta winner 2017
Mezzalama winner 2017
World Cup winner vertical 2017
EC vertical and sprint silver 2017

FASTEST KNOWN TIME (FKT)
Kebnekaise 2hrs 01 min, 2,106 mas
(meters above sea level)
Start from Kebnekaise fjällstation
up and return
Matterhorn 7 hrs 05 min, 4,478 mas,
Start from Cervinia up and return
Mont Blanc 8 hrs 10 min, 4,810 mas,
Start from Chamonix up and return
Grand Teton, 2 hrs 52 min, 4,197 mas,
start from parking up and return

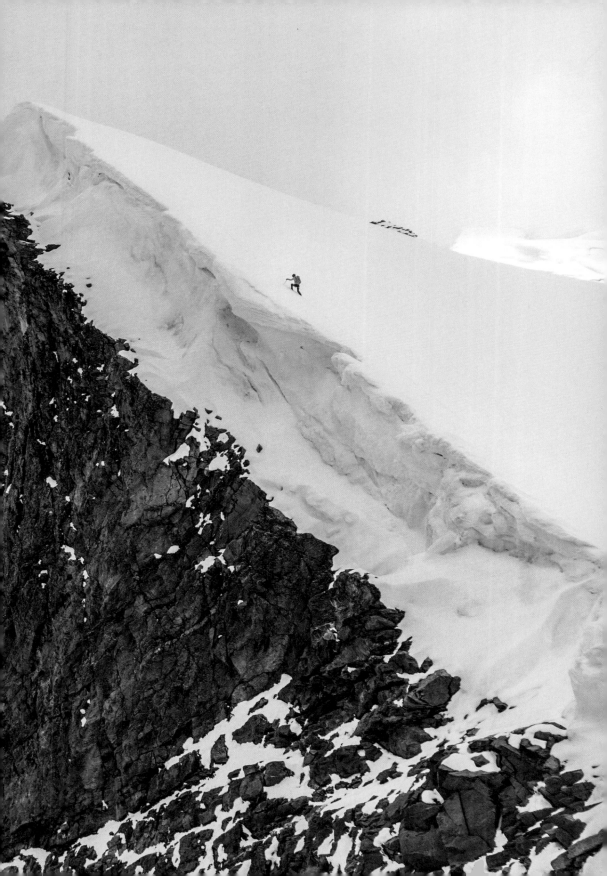

Thank You All!

My thanks to my publisher **Charlotte Gawell**, and my editor **Malin Bergman**. You've been eternally present and accessible throughout the writing process, for brainstorming and reflecting. But above all, you believed in me. It's been an amazing journey, and I'm deeply grateful for having done it. I'm so glad we met and get to have this experience together.

Also, my big thanks to **Kai Ristilä** for putting the book together into a beautiful layout, and to **Sara Orstadius** for translating the book into English.

Thank you **Linda Berg**, for discussing the expression "freedom" with me during a run at Handölan.

Thank you **Erika Borgström, Fanny Borgström** and **Ida Nilsson** for sharing your thoughts; philosophizing about life together with you is such an ease and joy!

Thank you **sis**, **Lilli-ann** and **Bengt,** and my dear **grandmother**, for your wise view of life.

And of course, dear **Kilian**, thank you for all your work and effort with the beautiful, soulful pictures in this book, but primarily, thank you for all the inspiration you give me!